Ge
and

HETTNER-LECTURES

Series editors:
Hans Gebhardt and
Peter Meusburger

Managing editor:
Michael Hoyler

Volume 9

Department of Geography
University of Heidelberg

Geographical imagination and the authority of images

Hettner-Lecture 2005
with
Denis Cosgrove

Franz Steiner Verlag 2006

Bibliografische Information der Deutschen Bibliothek
Die Deutsche Bibliothek verzeichnet diese Publikation
in der Deutschen Nationalbibliografie; detaillierte
bibliografische Daten sind im Internet über
<http://dnb.ddb.de> abrufbar.

ISBN 3-515-08892-X
ISBN 978-3-515-08892-3

ISO 9706

© 2006 by Franz Steiner Verlag GmbH, Stuttgart.
Druck: Printservice Decker & Bokor, München.
Printed in Germany

Contents

INTRODUCTION

Introduction: Hettner-Lecture 2005 in Heidelberg

PETER MEUSBURGER and HANS GEBHARDT

The Department of Geography, University of Heidelberg, held its ninth 'Hettner-Lecture' from 27 June to 1 July 2005. This annual lecture series, named after Alfred Hettner, Professor of Geography in Heidelberg from 1899 to 1928 and one of the most reputable German geographers of his day, is devoted to new theoretical developments in the crossover fields of geography, economics, the social sciences, and the humanities.

During their stay, the invited guest-speakers present two public lectures, one of which is transmitted live on the Internet. In addition, several seminars give graduate students and young researchers the opportunity to meet and converse with an internationally acclaimed scholar. Such an experience at an early stage in the academic career opens up new perspectives for research and encourages critical reflection on current theoretical debates and geographical practice.

The ninth Hettner-Lecture was given by Denis Cosgrove, Alexander von Humboldt Professor of Geography at the University of California, Los Angeles. Since the publication of his landmark study *Social formation and symbolic landscape* (1984), Denis Cosgrove has established himself as a leading scholar in cultural geography. With theoretically engaged and empirically rich studies of the changing meanings of landscape in the West, Cosgrove has contributed profoundly to the development of the humanities tradition in geography over the past twenty years (e.g. *The iconography of landscape: essays in the symbolic representation, design, and use of past environments*, edited with Stephen Daniels (1988); *The Palladian landscape: geographical change and its cultural representations in sixteenth-century Italy* (1993)). Cosgrove's recent work has explored the role of representations in the making of geographical knowledge and imagination, for example in his celebrated study of the representational history of the earth as globe, *Apollo's eye: a cartographic genealogy of the earth in the western imagination* (2001), or in the edited collection *Mappings* (1999). Cosgrove's work on landscape, representation, art and the geographical imagination continues to inspire new generations of geographers engaged in the exploration of their material and imagined environments.

During the Hettner-Lecture 2005 Denis Cosgrove presented two public lectures entitled 'Apollo's eye: a cultural geography of the globe' and 'Landscape, culture and modernity',[1] both of which are published here in revised form, together with an essay

[1] 'Apollo's eye: a cultural geography of the globe', *Alte Aula der Universität*, Monday, 27th June 2005, 18.15; afterwards reception. 'Landscape, cultur and modernity', *Hörsaal des Geographischen Instituts*, Tuesday, 28th June 2005, 15.15. The second lecture was followed by a public discussion, chaired by Benno Werlen (Jena).

on 'Regional art', a biographical interview and a short photographic documentation. Three seminars with graduate students and young researchers from Heidelberg and twelve other European universities took up issues raised in the lectures. The seminars were entitled 'Landscape and iconography', 'Mapping and imagination', and 'The geographic tradition and the humanities'.

We should like to express our gratitude to the *Klaus Tschira Foundation* for generously supporting the Hettner-Lecture. Particular thanks are due to Dr. h.c. Klaus Tschira, our benevolent host in the *Studio* of the foundation's magnificent *Villa Bosch*. We also thank Prof. Dr. Peter Comba, Vice-Rector of Heidelberg University for his welcome address at the opening ceremony in the university's *Alte Aula*.

The Hettner-Lecture 2005 would not have been possible without the full commitment of all involved students and faculty members. We thank Jana Freihöfer, Tim Freytag and Heike Jöns for their effective organisational work and the planning and chairing of the seminar sessions with graduate students and young researchers. We are also grateful to the students who helped with the organisation of the event. The concerted effort and enthusiasm of all participants once more ensured a successful Hettner-Lecture in Heidelberg.

APOLLO'S EYE: A CULTURAL
GEOGRAPHY OF THE GLOBE

Apollo's eye: a cultural geography of the globe

DENIS COSGROVE

The globe is Geography's icon. Although academic geographers commonly express irritation at the popular expectation that they should possess an encyclopedic knowledge of its surface (longest rivers, capital cities, mountain chains, or state boundaries), and embarrassment in the face of the claims to universal science that such an object of study seems to entail, the image of the globe remains stubbornly attached to the idea of Geography.

Yet the globe in its globality is little considered among contemporary geographers. To be sure, we examine economic, political and cultural *globalization*, and we research *global* environmental change. But within such geographic conversations the globe itself as a unitary, material object is taken for granted: an agreed, known, enduring phenomenon, its 'globality' as a terraqueous sphere, the unitary home of life, located in fixed spatial relations to other spheres, its varied motions governed by the laws of physics and chemistry, are taken to be settled scientific matters.

We know that this was not always the case; that as recently as the early 19th century an intellectual giant such as Alexander von Humboldt could sustain an international scientific reputation by seeking a synthetic understanding of the unity in diversity of the globe within the cosmos, drawing on the geographical skills of exploration, field observation, and mapping.[1] But for all the respect we geographers still give to von Humboldt as a founding figure of the modern discipline (especially in Germany), our progressive view of science figures him as the last of the cosmographers as much as the founder of modern scientific Geography.

Von Humboldt is not the object of this paper – which is to explore the idea and image of the globe as a cultural object, its enduring iconic significance, especially for science. But von Humboldt's work does offer an introduction to two key ideas that will inform my argument. First, his use of the scientific diagram and thematic map as key persuasive elements within his scientific writing is commonly remarked upon by historians of science, who have in recent years paid increasing attention to the roles played by such graphic materials in building a culture of modern 'science' as an empirical, objective and authoritative practice.[2] Second, is von Humboldt's attention

[1] Humboldt's scientific reputation was established of course principally through his field excursions in South America, but his continued status as an intellectual giant of the nineteenth century and the crowning synthesis of his life's work remains the two-volume *Cosmos: A sketch of a physical description of the universe* (1847) [English translation by E.C. Otté (1850), reprinted with an introduction by Michael Dettelbach, Baltimore & London: The Johns Hopkins University Press, 1997].

[2] The literature on the role of pictorial images in modern science is now very large. Classic studies include: Lorraine Daston and Peter Galison, 'The image of objectivity', *Representations* 40 (1992)

to the cultural history of geographical knowledge (Geography as *Geisteswissenschaft*, not merely *Naturwissenschaft*). He devotes Volume II of *Kosmos* to 'incitements to the study of nature' and a 'history of the physical contemplation of the universe' opening his study with a review of the role of imagination and poetic descriptions of nature, reminding us that the roots of scientific endeavor reach beyond the rational and instrumental, into the deeper grounds of the aesthetic and spiritual.[3]

My title, *Apollo's eye*, is taken from the book I published in 2001, in which I traced a genealogy of the globe as an imaginative and poetic object in European and hence Western culture.[4] A sun-god, Apollo had his epiphany in the *genius loci* of topographically significant earthly places: the island of Delos for example, and most importantly the sacred center of Delphi where the pre-Socratic philosopher, Anaximander located the *axis mundi* of Greek cartographic space, claiming that it lay at the point where the middle line of temperate latitude that ran from the Pillars of Hercules to Mount Ararat intersected the meeting point of two eagles sent by Zeus from the earth's opposite poles. Apollo's association with the clear light of disinterested reason (as opposed to Diana's lunar translucence or Dionysus' visceral passion) derives from the sun-god's separation from earthly attachment. Positioned to observe the turning world, he casts a dispassionate eye over the contingencies of quotidian life on earth. Sight is the sense most immediately connected with this god of light, and sight is at once the most distanciated of the human senses, and the one most closely associated with geographical knowledge and its techniques of observation, autopsy, discovery, survey and mapping.[5] The other sense with which we associate Apollo is music, but his is no human music. Rather, it is the cosmic harmony of the spheres whose incorruptible and perfect rotation produces an intellectual and spiritual harmony, audible only with deep study, contemplation, and self-discipline.[6] Given these qualities, it is hardly surprising that for Christian

pp. 81-128; Caroline A. Jones and Peter Galison (eds.) *Picturing science, producing art* (New York: Routledge, 1998); Barbara Maria Stafford, *Artful science: Enlightenment, entertainment, and the eclipse of visual education* (Cambridge, Mass.: MIT Press, 1994); Martin Kemp: *The science of art: Optical themes in Western art from Brunelleschi to Seurat* (New Haven & London: Yale University Press, 1992).

[3] Humboldt, Cosmos *op. cit.*, Vol. II, pp. 19-21.

[4] Denis Cosgrove, *Apollo's eye: A cartographic genealogy of the earth in the Western imagination* (Baltimore & London: The Johns Hopkins University Press, 2001).

[5] A significant literature critical of geography's close connection with sight (often referred to as 'the gaze' and drawing on the feminist and film studies literature that coined the term) has developed since 1990. It is most clearly articulated by Gillian Rose, *Feminism and geography: The limits of geographical knowledge* (Cambridge: Polity Press, 1993). The criticism informs much of Derek Gregory's argument in his 1997 Hettner lectures: *Explorations in critical human geography* (Heidelberg: Department of Geography, University of Heidelberg, 1998). The distinction between seeing, gazing, and vision – the last involving imaginative investment on the part of the subject, is rarely if ever made in this literature.

[6] Fernand Hallyn, *The poetic structure of the world: Copernicus and Kepler* (New York: Zone Books, 1993).

believers, Apollo should mutate easily into Jesus Christ: celestial god become terrestrial man. As we shall see, the image of Apollonian light extending from the heavens to the four continents of earth became a theme in the iconography of the Catholic Church's global mission.

The figure of Apollo signals two aspects of the globe that will structure my argument. The first is that for humans, the earth's globality cannot be experienced from its surface. To grasp the spherical form of the earth requires an act of imagination; it is en-visioned. The globe is made visible to us by means of three, or more commonly two, dimensional representations: globes, maps and today, remotely sensed images. This remained absolutely true until December 1968, when the Apollo 8 mission approached the Moon, and it remains the case for all but the twelve, now aging, Americans who have traveled sufficiently far from the earth's surface to witness the whole turning globe. If the globe is experienced solely through graphic representations it is correct to call it a *vision*, and we should pay special attention to the role played by imagination in the construction of global images and the meanings attached to them. The other aspect of the globe to which Phoebus Apollo draws attention, is his mediating position between heavens and earth. This serves to remind us that, for most of its history in the West, Geography was inseparable from cosmography, the science whose responsibility was to consider the Earth in its totality, unity and structure.[7] Cosmographers viewed the earth from the perspective of the Heavens, the two parts together making up 'the World.' In the words of Henry Hondius:

> God has placed us on the earth and below the skies; so that in lowering our eyes we might inspect the earth, while in raising them we might contemplate the heavens. Looking upwards and attentively considering this admirable machine of the world we become astronomers. Lowering our gaze towards the earth, and making measure of its extent, we are geographers. By means of these two sciences man renders himself a worthy inhabitant of the world.[8]

This formulation may seem quaint to a 21st century geographer, for whom study of the global surface has long been separated from astronomical and certainly cosmological concerns, and dis-enchanted. Yet, as I shall show, the cosmographic remains part of our discipline's heritage. I also believe that Hondius' claim that the science of geography renders us worthy inhabitants of the world remains an important dimension of geographical scholarship. It is these contexts that I examine here, structuring my presentation around three selected global images taken from

[7] The most comprehensive recent discussion of cosmography and its relations to geography is Jean-Marc Besse, *Les grandeurs de la terre: Aspects du savoir géographique à la Renaissance* (Paris: ENS Editions, 2003). See also my essay on cosmographic images in David Woodward (ed.) *The history of cartography* Vol. III, 'The European Renaissance' (Chicago: Chicago University Press, 2006).

[8] Quoted in Besse, Grandeurs de la terre *op. cit.*, p. 126.

different historical moments of geographical representation. These are a world map illustrating the text of the Classical, Neo-Platonic writer Macrobius' *Commentary on the dream of Scipio*, Oronce Fine's 'cordiform' world map of the 1520s, and the photograph of the whole earth taken from Apollo 17 in 1972 and numbered AS-17 22727 by the United States' space agency NASA. In my closing remarks I shall suggest reasons why geography might again profitably give attention to the cosmographic scale, raising its eyes towards the heavenly parts of 'this admirable machine of the world'.[9]

Macrobius: mappa-mundi

No terrestrial globe of which we have certain knowledge predates that constructed by Martin Behaim in Nuremberg in 1492. And while Claudius Ptolemy's 2nd century *Geography* assumes the sphericity of the earth in demonstrating methods for its projection onto a planisphere[10], there is no indication that models of the globular earth were constructed in the ancient world. Indeed, until Magellan's circumnavigation of 1522, there was little point in producing such an object. Beyond the unitary land mass centered on the Mediterranean Sea and stretching through 180 some degrees of longitude, and about 80 degrees of latitude, the globe's surface was believed to be occupied by water. To be sure, there was speculation about an antipodean continent, and even occasionally about two more continents (*perioikoi* and *antoikoi*), north and south, balancing the *oikoumene* and *antipodes* in opposite longitudinal hemispheres. But all these lands remained matters of speculation, because whatever might exist in the three other hemispheres was inaccessible to humans living in the *oikoumene* – the habitable part of the earth [Figure 1]. The torrid and frigid zones, north and south respectively, and the circumambient ocean acted as barriers to human movement. Cold and heat restricted latitudinal movement; the chaos and flux of *Okeanos* restricted navigation longitudinally. Indeed, for medieval readers, Aristotle's physical theory offered a strong theoretical argument that no other continents existed beyond the tripartite world island: as the heaviest element, Earth should theoretically be completely covered in water (and further encircled by

[9] The phrase is taken from Daniele Barbaro's 1557 translation and commentary on the Roman architectural writer Vitruvius' *Ten books of architecture*, where Barbaro cautions the architect to consider 'this admirable machine of the world' before proceeding to construct an edifice. 'Machine of the world' was a commonplace term for the cosmos in the 16th century; Shakespeare uses similar phrasing more than once.

[10] J. Lennart Berggren and Alexander Jones, *Ptolemy's Geography: an annotated translation of the theoretical chapters* (Princeton & Oxford: Princeton University Press, 2000).

air and fire.[11] Only an eccentricity of the spheres of water and earth allowed the latter to protrude through the waters, and logically this could occur only at one location.

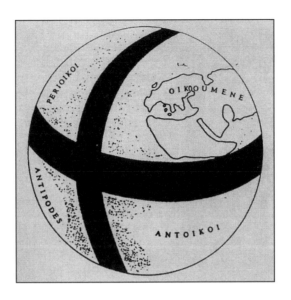

Figure 1 The ecumene and speculative global lands and seas in the geography of Crates
(From Jean-Marc Besse, *Les grandeurs de la terre: Aspects du savoir géographique à la Renaissance*
(Paris: ENS Editions, 2003) p. 59. Reproduced with permission)

From 12th century crusading contacts with Arab scholars, Latins learned Aristotelian cosmology, henceforth taught in the Schools, often through summary works by such writers as Sacrobosco and Proclus. Manuscripts and later printed editions of these texts reproduced diagrams illustrating the elemental and celestial parts of the world and the relations between them [Figure 2]. But these gave scant attention to the central cosmographic question of the globe's surface patterns. Such images are to be found primarily in sacred and eschatological representations: the *mappae mundi* created in great monasteries and cathedrals, and illustrations of Creation or of the Apocalypse – the origins and ends of space and time. One of the few secular exceptions is the 2nd century Roman author Macrobius' *Commentary on the dream of Scipio*, long treasured also as a theoretical text on the nature of dreams.[12]

[11] Jean-François Staszak, *La géographie d'avant la géographie: Le climat chez Aristote et Hippocrate* (Paris: L'Harmattan, 1995).

[12] Macrobius, *Commentary on the dream of Scipio* (Translated by William Harris Stahl, New York: Columbia University Press, 1952).

Figure 2 Cosmographic diagrams showing the Aristotelian cosmos, adapted from Sacrobosco:
the armillary sphere (left), and the elemental and celestial spheres (right).
(From Caesare Caesariano: *Architectura Libri X*, Vitruvius, Venice, 1520)

The text for Macrobius' commentary is the final book of the Roman jurist Cicero's
De Re Publica, where the story is told of how the great grandson of Scipio Africanus,
conqueror of Carthage returns to the site of the African victory, and in a dream
ascends to the starry heavens where he is shown his ancestor, now deified and a
vision of the cosmos spread before him. The work opens with a Platonic claim about
the incorruptibility of the human soul: 'made out of the undying fire which make up
stars and constellations, consisting of spherical bodies animated by the divine mind,
each moving with marvelous speed, each in its own orbit and cycle. It is destined that
you and other righteous men suffer your souls to be imprisoned with your bodies.'[13]
Escaping through the dream his corporeal prison, the younger Africanus is shown
the order of the heavens and the great features of the earthly globe.

When I gazed in every direction from that point, all else appeared wonderfully beautiful.
There were stars which we never see from the earth, and they were all larger than we have

[13] Cicero, *De Re Publica* (Translated by C.W. Keyes, Loeb Classical Library, London: Heinemann,
1928) p. 267.

ever imagined. The smallest of them was that furthest from heaven and the nearest the earth [the Moon] that shone with a borrowed light. The starry spheres were much larger than the earth; indeed the earth itself appeared so small that I was scornful of our empire, which covers only a single point, as it were, upon its surface.[14]

The text contains a detailed description of the climatic zones and the pattern of lands and seas on the earth's surface. It is a *locus classicus* of the 'cosmographic dream,' a literary genre that would echo through European imaginative and scientific literature (Luis de Camões, John Milton, Johannes Kepler and Athanasius Kircher are among its better known exemplars).[15] The young Scipio's humbling recognition of how small a part of its surface is occupied by an empire that claimed dominium *ad termini orbis terrarum* becomes a standard trope within the cosmographic dream.

Commentary on this text had to negotiate a central problem of cosmography. If the pattern and harmony of celestial motion are inscribed on the globe's surface (poles, great circles, etc), should not its elemental geography of land and water also betray a harmonious pattern? The earth's axis and rotation with respect to the sun's produces the latitudinal banding of *klimata* (climates). These were simplified by Classical science into the familiar five zones that long served as a geographical short hand: two frigid, two temperate and a torrid zone, circling the earth [Figure 3]. On the other hand the elemental distribution of land and water produced a tri-continental landmass whose location bore no systematic relation to these mathematically determined zones. A relationship between the two patterns could be indicated by determining that the *oikoumene* was centered upon the temperate zone, its central region occupied by the 'Middle Sea,' or Mediterranean. The argument could best be made graphically.

Two points may be made about Macrobius' global geography. First, it was driven by a philosophical commitment to logical pattern and symmetry in the cosmos, a desire that the elemental earth reflect not only the order of the heavens, but as far as possible the harmonious relationship of all parts of the cosmos. That urge was fundamentally Stoic, and the cosmographic dream and its map may almost be regarded as Stoic motifs. In Stoic thought, the cosmos was viewed as the rational creations of a divine mind. Its order provided the logical foundation for individual human reason and social harmony. This recognition provides the foundation for virtue in the suppression of the passions and the embrace of all civic life. A duty of care extends to the whole of creation. Writers such as Seneca and Cicero himself argued for a Stoic cosmopolitanism that grew from their philosophical commitment to disinterested reason and embrace of humanity. The cosmopolitan vision could be attained most readily from a position spatially and emotionally removed from the

[14] Ibid., p. 269.
[15] Cosgrove, Apollo's eye *op. cit.*, pp. 162-165.

fixed attachments, loyalties and shifting passions of family, city and nation – all territorially bounded and located in place. Cicero declared that, despite apparent differences, all the earth's peoples shared the common characteristics of reason, sociability and an urge towards the divine. These elements made for human unity.[16]

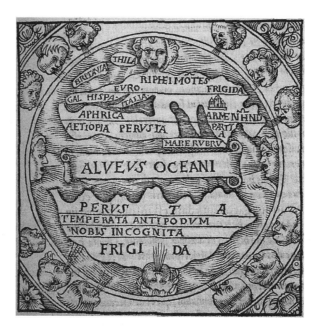

Figure 3 Macrobius: Distribution of lands, seas and climatic zones
(From Jean-Marc Besse, *Les grandeurs de la terre: Aspects du savoir géographique à la Renaissance*
(Paris: ENS Editions, 2003) p. 57. Reproduced with permission)

The second point to be made about *The Dream*'s theoretical geography is that it is most convincingly argued through the medium of a map. The relation between the climatic zones and the patterns of land and sea can be rapidly grasped in a simple graphic. It is not surprising therefore that among the earliest secular maps in the Western tradition are those made to illustrate Macrobius' *Commentary*, in manuscript and later printed editions of his work [Figure 3]. This 'Macrobian' map shows the three named continents stretched across the northern part of the visible hemisphere, fitted as symmetrically as possible into a clearly demarcated and labeled temperate zone. This island *oikoumene* does not reach as far as the equator (although the Classical geographers summarized by Ptolemy in the same century as Macrobius had

[16] The Stoic argument and its relations to cosmopolitanism are more fully articulated in my paper 'Globalism and tolerance in early modern geography', *Annals, Association of American Geographers* 93 (2003) pp. 852-870.

14

mapped lands as far south as the climate of anti-Meroe: c.16°25'S latitude). The ecumene is encircled by the Ocean Stream, and on most maps balanced by an antipodean continent whose existence and form reflects the same Stoic desire for symmetry that makes the Mediterranean such a central and extensive feature of the temperate zone. The map should be regarded more as an icon or emblem of Stoic order and an object of neo-Platonic contemplation than as a scientific instrument.

Yet, as an illustration of global geography, this map and Macrobius' text acted as principal sources for the Medieval understanding of the earth's surface forms. As such, they were used didactically, alongside Classical works such as Pliny's *Natural History* and Pomponius Mela's *De Situ Orbis*, and the early medieval Isidor of Spain's *Etymologia*. Today, most philologists study the geographical elements of Macrobius' text separately from its oneiric concerns, which are of interest for the pre-history of Freudian dream theory. But as a neo-Platonic work whose sources lie deep in the Stoic tradition, the geographical and psychological aspects of Macrobius' text form a unity, whose principal concern is the moral question of the human relationship with the globe and its peoples.[17]

Oronce Fine's cordiform map

The great French mathematician and cosmographer to the French king François II, Oronce Fine is best remembered today as the inventor of triangulation as a method of topographic survey, as well as for his mathematical and cosmographic texts, for example the *Protomathesis* (1532). His elaborately framed world map of 1534, based on a 1519 manuscript map and dedicated to François, has long been regarded as at once a masterpiece of Renaissance map art, and a 'cartographic curiosity' [Figure 4]. It is mathematically sophisticated to be sure: an equal-area map of the globe, encompassing the newly expanded, post-Columbian *oikoumene* of the early 16th century across a full 360° of latitude. It makes clever use of the planisphere's necessity to cut and open the sphere along the 180th meridian in order to evade the question of whether a continental connection existed between the old and new worlds. The lines of longitude curve symmetrically around the prime meridian, on which the degrees are correctly proportioned to those of the parallels, giving the map a three-dimensional visual effect. Oronce's planisphere was not especially practical, although it was an important stage on the route to Gerardus Mercator's 1546 resolution of the spherical and planar modes of global construction. The map was one product of the astonishing flowering of global representations that occurred in

[17] For a fuller discussion of the connections between the map and dream theory see my essay 'Geography's cosmos: the dream and the whole round earth,' in K. Till, S. Hoelscher and P. Adams (eds.) *Textures of place* (Minneapolis: University of Minnesota Press, 2001) pp. 326-339.

the second and third decades of the 1500s. Model globes and planispheres experimenting with different projections were an immediate consequence of the European desire to visualize a terraqueous surface that was truly global, and the practical needs of European monarchs and their diplomats to determine the geopolitical division of the sphere, in the immediate aftermath of circumnavigation. In those still early years of printing, the world map was a rare, precious and even numinous image, far removed from the familiar, even banal, object of today.

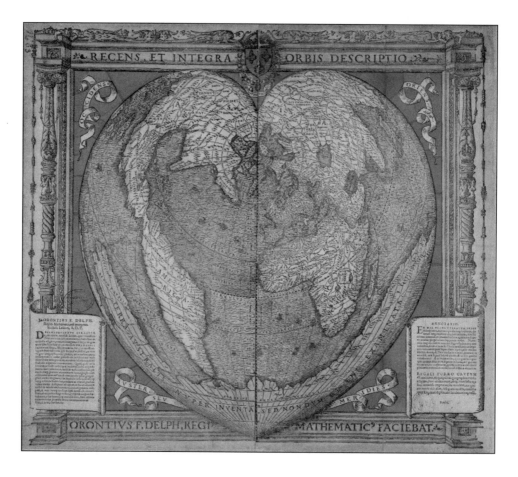

Figure 4 Oronce Fine: *Recens et integra orbis descriptio* (1534/36). Woodcut cordiform map. (Reproduced by permission of the Bibliothèque Nationale de France)

Oronce Fine's projection is named for the heart-shaped form into which it casts the globe: *cordiform*. Fine was not the first to use this form, it emerged from the theoretical work of Bernardus Sylvanus, Joseph Werner and the mathematician and poet Johannes Stabius. In 1515, collaborating with Albrecht Dürer, Stabius had plotted the first perspective view of the earth's surface as seen from the heavens: a picture of the globe for the German Emperor Maximillian I. In a recent, detailed examination of the origins of the cordiform map, the New Zealand artist Ruth Watson (many of whose contemporary art works make use of the long-abandoned projection, but invert it by placing South at the top) has explored the emblematic significance of the heart in late Medieval thought.[18] Today the human heart is viewed scientifically as a pumping mechanism, and associated emotionally almost exclusively with romantic love. For Stabius and Fine – trained like so many sixteenth-century cosmographers as physicians – the heart was a much more complex and mysterious organ. It was the primary receptor of sensation, the seat of memory, the portal to wisdom and above all the governor of that microcosm that is the human body. Many of its supposed functions are today attributed to the brain. Cosmologically, the heart was the Sun, center of the world. It was thus frequently removed from the royal body at death of the king and buried separately (as was the case with François II himself). Moreover, the emerging science of human anatomy was making the heart and its role in the circulation of blood a matter of speculation and mystery.[19] Presenting a world map in the shape of a heart thus connected the image of a newly expanded globe to the most intimate core of the human individual, to the idea of rule, and to the majesty of monarchy and empire. The conceit that in holding the map the ruler holds the territory is long-standing: Augustus, first Roman emperor, initiated the iconography of the globe as an imperial symbol. The symbolism of the globe was widely revived among European monarchs in the sixteenth century as they projected *imperium* over global space, and for this the heart shape was uniquely appropriate.

Among the many qualities ascribed to the heart, that of selfless love is a constant. The Christian image of the 'Sacred Heart' associates Christ's divine redemptive act with his human body. The Christian image long pre-dated the appearance of the cordiform map, but the cult of the Sacred Heart saw renewed vigor within the Counter Reformation Church, particularly within the Jesuit Order, founded in the same decade that Oronce's map was printed. The vault of the Jesuit's principal church in Rome, decorated in the 1690s by the artist Andrea Pozzo, is an allegorical geography of global salvation. In the artist's own words: 'In the middle of the vault I have painted the figure of Jesus, who sends forth a ray to the heart of Ignatius

[18] Ruth Watson, 'A heart-shaped world: Johannes Stabius, Oronce Fine and the meanings of the cordiform map' (PhD Dissertation, School of Art, Australian National University, 2005).

[19] Jonathan Sawday, *The body emblazoned: Dissection and the human body in the Renaissance* (London & New York: Routledge, 1995).

[founder of the Jesuit Order], which is then transmitted by him to the most distant hearts of the four parts of the world.'[20] Each continent is represented by an allegorical figure: sceptered Europe resting on the globe of faith. Pozzo's iconographic scheme is anticipated in Stephen Eggestein's 1664 emblem, in which the four continents are brought into the light of Christian faith and kneel before the eucharist, celebrated at an altar whose cloth is decorated with a cordiform global map.[21]

The cordiform map was not the sole preserve of Catholic emblematic geography. It is found in devotional devices on both sides of Europe's religious divide. As makers of global images, 16th century cosmographers practiced a dangerous craft. Their representations of the cosmos unavoidably trespassed on theological questions around which Europeans were slaughtering one another. Both Fine and Mercator were accused of heresy, and Mercator actually imprisoned. Many cosmographers, including both Mercator and Abraham Ortelius, adopted an Erasmian interpretation of faith, which emphasized interior belief and public tolerance and was deeply rooted in neo-Stoicism. The Family of Love, of which Ortelius was a keen adherent, was an international group of largely scholarly people who followed such a path. They believed in free will, the voluntary acceptance of authority, rejecting the extremes of both Calvinism and Tridentine Catholicism. Their emblem was the heart, which may account for the popularity of the cordiform map in the published works and private correspondence of these cosmographers.[22]

Ortelius' hugely successful atlas: *Theatrum Orbis terrarum* opens its graphic survey of the four quarters of the earth with a world map. While not cordiform, it makes explicit reference to the Stoic philosophy of witnessing the globe from afar. In the map's first version of 1570 the earth emerges from clouds of unknowing. A Latin inscription below reads 'For what can seem of moment in human affairs for him who keeps all eternity before his eyes and knows the scale of the universal world?' Cicero's words reinforce the metaphor of 'theater' in the work's title: the globe is a stage upon which human tragedy and comedy unfold. This map, and by implication the regional maps that follow, present the earth philosophically, as a part of the 'universal world' – the cosmos. The atlas as a whole is an object of moral contemplation and reflection. When Ortelius had the map re-engraved in 1587, he took the opportunity to reinforce the emblematic significance of his opening planisphere. In addition to

[20] Quoted in Cosgrove, Apollo's eye *op. cit.*, p. 160.

[21] Giorgio Mangani, 'Abraham Ortelius and the hermetic meaning of the cordiform projetion', *Imago Mundi* 50 (1998) pp. 59-83.

[22] For a fuller discussion of cosmography religion in the period, see Giorgio Mangani, *Il 'mondo' di Abramo Ortelio: misticismo, geografia e collezionismo nel Rinascimento dei Paesi Bassi* (Modena: Franco Cosimo Panini, 1998), and Nicholas Crane, *Mercator: The man who mapped the planet* (London: Weidenfeld & Nicolson, 2002).

the original epigram, four medallions appear at the corners of the earth. Each contains a Latin inscription, two from Cicero and two from Seneca:

Top left: 'For man was given life that he might inhabit that sphere called Earth, which you see in the center of this temple' (Cicero)

Top right: 'the purpose of the horse is for riding, of the ox for ploughing, of the the the dog for hunting and keeping guard; the purpose of man along is contemplating the world' (Cicero)

Bottom right: 'I desire only that philosophy should appear before us in all her unity, just as the whole breadth of the firmament is spread before us to gaze upon' (Seneca)

Bottom left: 'Is this that pinpoint which is divided by sword and fire among so many nations? How ridiculous are the boundaries of mortals! (Seneca)

From Oronce Fine to Abraham Ortelius and Gerardus Mercator, we may observe the key figures of Renaissance geographical science using the iconography of a rapidly changing and challenging globe to encourage and express a philosophical contemplation of the earth in relation to the heavens, to sustain the belief in a homology of world and human body, and a cosmopolitan, Stoic commitment against bigotry and intolerance and in favor of harmony among the diverse peoples of the earth.

AS-17 22727

For my last image, I jump to the mid-20th century 'space race,' part of the Cold War competition between two universalizing ideologies for global allegiance. The *space* for which the USA and USSR raced is the dis-enchanted and secular equivalent of what Macrobius, Oronce Fine or Gerard Mercator called the 'heavens'. *Space* stretches boundlessly and inconceivably, and within it the planetary globe is an insignificant speck whose only centrality is that attributed to it by human imagination. 20th century theories of relativity and quantum mechanics appeared to complete the de-centering of the globe that began with Copernicus *De Revolutionibus* of 1543. The 1961-72 Apollo lunar-landing project seemed to confirm the victory of the Baconian project of aligning experimental modern science to technology in order to explain and mobilize the forces of nature for human ends. Ironically, its most enduring legacy is an image that appears to articulate a profound challenge to modernist, scientific hubris [Figure 5].

Apollo 17 was the final lunar mission, launched in the face of declining public interest and enthusiasm for a race that had clearly been 'won' by the USA. No astronaut has subsequently been propelled far enough from earth to witness its full sphericity. That final 1972 mission returned with a photographic image that remains unique: a single frame, taken with a hand-held camera that shows an un-shadowed

earthly disk.[23] On its surface, beneath zonal bands of cloud, are visible the outlines of Africa, South Asia, Antarctica, and slivers of Europe, South America and Australia. The challenges that Aristotelian cosmographers sought to resolve are graphically apparent. The distribution of lands and seas reveals no logic or mathematical symmetry. The climatic zones, apparent from the bands of color and atmospheric circulation in the inter-tropical zone, the Southern jet stream and the foggy pole, are imprecise and fluid. But the remarkable thing about this image of global geography – whose graphic influence is responsible for the virtual disappearance of latitude and longitude lines from globes and world maps today – is that it is universally interpreted as a vision of unity and harmony. But it is a unity and harmony understood to emerge from the delicate interplay of forces and processes operating within the material world, not imposed by a source of reason located beyond the planet.

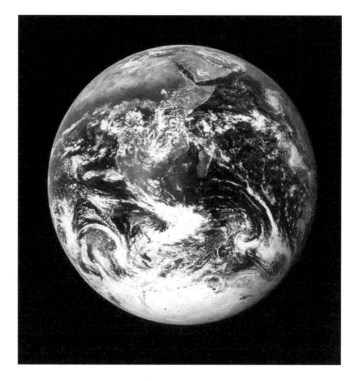

Figure 5 NASA: AS17/22727. The 'whole earth' image (1972)

[23] The detailed story of this image, its making and subsequent evolution into a key icon of the late 20th century is told in my paper, 'Contested global visions: *One World, Whole Earth*, and the Apollo space photographs', *Annals, Association of American Geographers* 84 (1994) pp. 270-294.

The meaning and impact of this photo 22727 – the whole earth – did not arise unprompted from the image itself. It was the outcome of a complex cultural process, of which the cosmographic history I have been tracing here forms a significant part. To understand this, we should return initially to the very first photographs taken of the whole earth from space by human observers. These had appeared four years earlier, at Christmas 1968, when the Apollo 8 astronauts circled the moon and returned TV images and later color photographs of the shadowed earth rising over the lunar surface [Figure 6]. 'Earthrise' was a sensation, broadcast to a global television audience across newly-established satellite links and the subject of a widely reprinted editorial piece in the Christmas Day edition of the *New York Times* by the American poet Archibald MacLeish. MacLeish titled his essay 'Riders on the Earth' and in it proclaimed that the view of our planet from the Moon, isolated in the dead blackness of space, constituted a revolution of Copernican dimensions, for it forced humans to acknowledge the bounds of life and the needs to share a small, fragile globe:

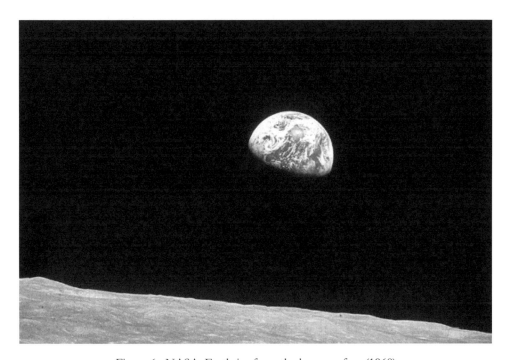

Figure 6 NASA: Earthrise from the lunar surface (1968)

To see the earth as it truly is, small and blue and beautiful in that eternal silence in which it floats, is to see ourselves as riders on the earth together, brothers in that bright loveliness in the eternal cold – brothers who know now that they are truly brothers.[24]

―――――――――――

[24] Quoted in Cosgrove, 'Contested global visions' *op. cit.*, p. 283.

It was a theme that the American poet had voiced over a quarter century earlier, in the aftermath of Pearl Harbor, when he discussed in an essay 'The image of victory' in what he referred to as the 'airman's war:'

> Never in all their history have men been able truly to conceive of the world as one: a single sphere, a globe, having the qualities of a globe, a round earth in which all the directions eventually meet, in which there is no center because every point, or none, is center – an equal earth which all men occupy as equals. The airman's earth, if free men make it, will be truly round: a globe in practice, not in theory.[25]

These sentiments were widely shared among mid-century, liberal American thinkers and had found expression in a uniquely American form of popular cartography. Maps printed in popular magazines and newspapers used highly pictorial techniques (often disparaged by professional cartographers as unscientific) to give a graphic impression of the globe's sphericity and the interconnection of peoples and places on its surface.

The American astronauts of the 1960s themselves reinforced the universalistic rhetoric articulated by MacLeish. Circling the Moon for the first time, the crew of Apollo 8 provided for a global TV audience an unscheduled cosmological performance by reading the creation narrative from *Genesis*. And, emerging from the Moon's dark side to the spectacle of Earthrise, the astronaut Frank Borman contrasted the vibrant colors and watery softness of Earth with the harsh lunar landscape: 'a grand oasis in the big vastness of space.' He went on to echo (almost certainly unconsciously) the sentiment expressed in the ancient Roman stoic, Seneca's lines, that had been reproduced on Abraham Ortelius' 1570 world map:

> When you're finally up at the moon looking back on earth, all those differences and nationalistic traits are pretty well going to blend, and you're going to get a concept that maybe this really is one world and why the hell can't we learn to live together like decent people.[26]

In the decades following the termination of the Apollo program, the two images of Earthrise and the 'Whole Earth' (22727) have become icons in their own right, widely reproduced, reworked and imitated. The whole earth especially became a poster for two somewhat divergent visions of globalism. It was appropriated by the environmental movement of the 1970s and 1980s, which drew upon an interpretation of the globe as a vulnerable home of life – human and non-human – that was in need of protection from the ravages of unrestrained technology, economic development, human greed and exploitation of nature. It was similarly popular with some of the most urgent promoters of technology and development: airlines, communications

[25] Archibald MacLeish: 'The image of victory' in Hans W. Weigert and Vilhjalmur Stefansson (eds.) *The compass of the world: A symposium on political geography* (London: George G. Harrap, 1944) p. 3.

[26] Quoted in Cosgrove, 'Contested global visions' *op. cit.*, p. 282.

firms and international finance which drew upon the idea of a global population drawn together in a world without borders and advancing towards a utopian future. Among the most powerful images derived from the 'whole earth' was the British artist Peter Kennard's photomontage in which he superimposed upon 22727 the other iconic image of the early 1970s: the first scanned picture of a foetus *in utero* [Figure 7]. Here too a longer historical association of the earth as macrocosm with the human body as microcosm (even its beating heart), which we have observed in the Macrobian text and cordiform map, gives Kennard's work a unusual depth and power.

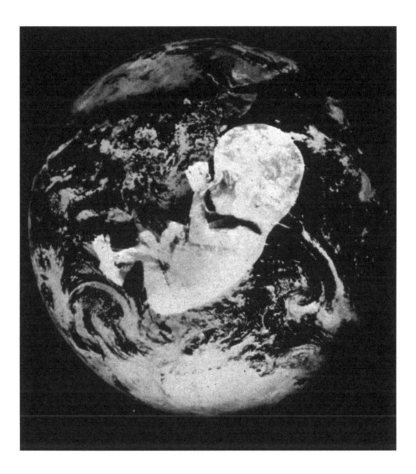

Figure 7 Peter Kennard: Photomontage (1990)

Conclusion

The earth will always be familiar to its inhabitants principally through images. Some will be three-dimensional globe models, but for all their greater accuracy than flat maps, globes will always play more of an iconic than a practical role in representing and communicating geographical knowledge. Globes are simply too cumbersome, too small scale and too expensive ever to escape their largely decorative role. From the earliest years of their widespread production, globes have principally served decorative and rhetorical purposes: signifying scholarship in the study or library, signifying power and authority in the courts of kings and diplomats, symbolizing global reach in the corporate offices of international companies such as airlines and telecommunications businesses. Even in the classroom they are emblematic rather than intensively used scientific instruments. The globe projected onto a two-dimensional surface as a world map or planisphere has always been the principal medium for communicating geographical knowledge of the earth's surface.

It is sobering to recall how recent is the 'completion' of the pattern of lands and seas visibility over the global surface – that mystery which taxed the imagination of cartographers from the Ancient World until the age of the satellite, and how contingent is our delimiting of the earth's habitability. In my university atlas of 1967, Antarctica's coasts remain sketched in part with lines of question marks. And the first photographic image showing the surface of the Antarctic continent free from cloud dates from the first years of the 21st century! The image of the globe has never been entirely dis-enchanted and will always demand vision; indeed its enchantment seems to have grown with our capacity to render it with ever-greater scientific accuracy. That is not to deny that with greater familiarity has come an almost contemptuous rendering of the globe image in recent years as a banal item of consumption: printed on tee-shirts, reduced to desk or key-ring ornaments, or kicked around as an inflated balloon. All these items are readily available from 'globe stores' in the USA.

But the three globe images I have presented and sought to contextualize here suggest a distinct genealogy of global meanings. Geographical science has never been completely divorced from cosmography: the concern with the place of the earth in the greater structure of creation. As we begin to place a human 'footprint' (embodied or mechanical) on the Moon and the planets, and thus bring them within the scope of cultural space, so the logic of restricting geography to the terrestrial surface retreats once again. Nor has the image of the globe been totally secularized. It remains a powerful icon of quasi-religious dimensions, an object of contemplation, sacred both in itself and in its reference. What is remarkable – at least in the Western tradition – is the consistency of the meanings attributed to the globe as a sign of perfection, purity and order, a macrocosm of the human body, conveying moral imperatives for its human inhabitants. These sentiments are rooted in the deep and

powerful traditions of Stoic and Platonic thought in the West. That the form and motion of the turning earth should be logically and necessarily tied to a greater order of the heavens, that the surface pattern of earth is both necessary and coherent (even if today we know it to be in constant change), that at a fundamental level the body of earth and the human body are connected, and that the capacity to see or grasp the earth as a whole, from the necessary distance of space, produces a strong intimation of the unity of all life: these responses to the global image are consistent across more than two millennia. Arising from these sentiments, we can observe with equal consistency appeals to individual transcendence and to cosmopolitanism – the cosmographic dream.

Cosmopolitanism and the liberal, humanist vision of global unity have been the objects of profound and sustained criticism in recent decades. They stand accused, at best of naivety in failing to recognize the inevitable positionality of any philosophical universalism, at worst of acting as ideological weapons in the cause of Western, patriarchal hegemony. There is unquestioned force in such criticism, especially given the historical alignment of global thinking – and the associated alignment of the image of the globe itself – with western imperialism and colonialism. But if geographical science as a search for unity in diversity – to use von Humboldt's famous phrase – has consistently been subordinated to the interests of power and control over territories and peoples, the geographical imagination as a probing curiosity about the logic of global space and about the baffling capacity of humans to establish commerce and conversation across the manifold differences that distance entails, has never entirely shed its innocence and its sense of wonder. In no small measure this is because as each individual person confronts the world anew and seeks to grasp the vastness of the globe on which and from which human existence takes its course, fundamental questions arise: who are we, how does where we live and where we travel help define us, and to what extent are we bound by our corporeal and terrestrial attachments? Each of the three global images I have examined – Macrobius, Fine, NASA AS17/22727 – presents to us in the guise of Apollo, an image of *oikoumene*, the habitable earth. In apparently prescribing the limits to human life, every image of the globe unintentionally reminds us that the spatial boundaries of material life do not proscribe the limits of human imagination. The globe tempts us towards cosmos. The globe is thus always an icon: a visionary form beckoning us beyond our material selves, inwards towards reflection, outwards towards geography.

LANDSCAPE, CULTURE AND MODERNITY

Landscape, culture and modernity [1]

Denis Cosgrove

My evening walk leads me up a steep hillside. I follow a turning road past an assortment of houses whose dizzying variety of styles – let alone their prices – would astonish most visitors, towards open upper slopes covered by semi-desert grasses and shrubs: California *chaparral*, the American equivalent of Mediterranean *maquis*. From the summit, depending on the clarity of the air that gave the Los Angeles basin its Indian name, 'place of smokes' long before it helped create the city's infamous smogs, I can gaze across groups of high-rise offices, commercial boulevards, palm-lined residential streets, billboards and red tiled roofs that stretch to the horizon. Turning through 180 degrees, my view from the Hollywood Hills sweeps from the snow covered San Gabriel Mountains to Pacific beaches and offshore islands. At night, when city lights pick out the grid of streets that structures this vast urban field, I am looking at one of the iconic landscapes of the twentieth century, a landscape that first gave rise to the term *urban sprawl*. It is the kind of landscape that causes conservative European writers (and a number of their American intellectual disciples) to such declarations as the following: 'It is absurd to ask whether these landscapes provide space for anything humane … The American way of life corresponds … to landscapes where one cannot be at home; it derives from the fundamental incapacity still to understand at all what it means to be at home'.[2]

In fact, many of the homes on my walk have been sited and designed precisely to capture this famous view; it constitutes much of their dollar value. Among the most quoted examples of modernist domestic architecture, Pierre Koenig's Case Study House # 22 [Figure 1], is less than a kilometer east from where I am standing. Cantilevered over the steep hill-slope, its entire spatial conception was governed by the illusion of flying out over the city into an aerial field of twinkling lights.[3] The plate-glass 'picture window' that both frames a picture view and erases the boundaries of internal and outdoor living is just one of the ways in which a unique blend of cultural modernity and the landscape idea have helped shape Southern California.

[1] A slightly altered version of this essay will appear in *The Journal of Material Culture* 11 (2007).

[2] Julia Lossau, 'The body, the gaze and the theorist', *Cultural Geographies* 12 (2005) pp. 59-76. For a thoughtful summary of the 'sprawl' debate in America and its connections to British and European anti-suburban ideology, see Robert Bruegmann, *Sprawl* (Chicago: University of Chicago Press, 2005). The book also discusses the changing polemics surrounding Los Angeles urban form.

[3] *Julius Schulman: Modernity and the metropolis* (Getty Research Institute Gallery, October 2005 – January 2006); Arthur Krim, 'Los Angeles and the anti-tradition of the suburban city', *Journal of Historical Geography* 18 (1992) pp. 121-138.

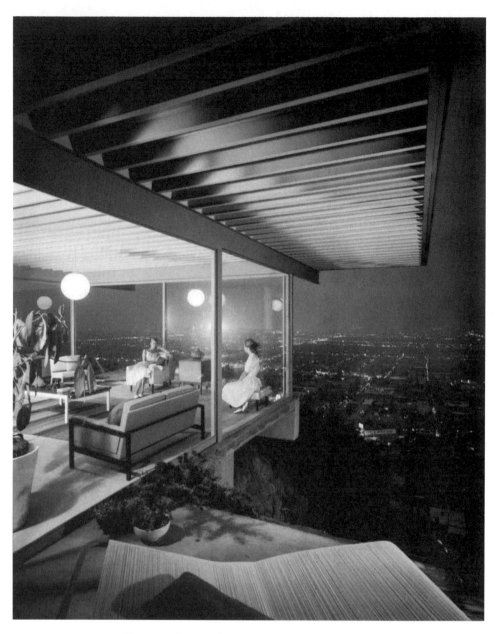

Figure 1 Case Study House #22 by Pierre Koenig
(Photo by Julius Schulman; Getty Research Institute)

Dominating this region's human geography, the Los Angeles metropolis is frequently cited as the *locus classicus* of a contemporary popular culture that is increasingly global in its penetration. Not only is this true in the obvious case of the

Hollywood movie industry with its constellation of cultural spin-offs – television and popular music, celebrity journalism, street fashion, colloquial speech – but of the city's diversity of ethnic groups, languages and lifestyles, its cultural politics, its cult of the automobile, its suburban 'edge cities,' and its residential morphology: in short, its landscape. The physical forms of suburban landscape that emerged in 1950s Southern California now stretch around the globe, as far as the outer reaches of Beijing and Shanghai.

In speaking of Los Angeles, I have thus far used the word *landscape* in three distinct, if overlapping ways: to describe extended, pictorial views from the Hollywood Hills which its houses are designed to frame; as an 'idea' that played a significant role in shaping California's modernity; and as a shorthand for the blend of land and life, of physical and social morphologies, that constitute the geography of a distinct region and community. *Landscape* is complex and multi-layered, difficult to categorize or to quantify. Landscapes have an unquestionably material presence, yet are brought into existence only at the moment of their apprehension by an external observer. These characteristics have made the term a frustrating one for geographers and others concerned with conceptual clarity and definitional exactitude. In Germany the early 20th century history of *Landschaftsgeographie*, and its close associations with questions of aesthetics and identity in the fascist period have made landscape an especially fraught concept within Geography. Beyond, in Art History, the idea of *Kunstlandschaft* was a central concept of pre-war German *Kunstgeographie* in the work of Josef Strzygowski and his followers at the University of Bonn, with similar contentious consequences.[4] In American geography, Richard Hartshorne, whose 1939 methodological study drew principally on German geographical sources, declared that *landscape* had 'little or no value as a technical scientific term.'[5] Yet in recent years the ambiguities that so irritated Hartshorne have been actively exploited by geographers who positively value landscape's capacity to smudge the binaries of nature and culture, of reality and representation, of symbol and referent. Contemporary scholarly thought, at least in the Anglo-Saxon academy, which is much focused on interdisciplinarity, strongly influenced by semiotics, and distrustful of rigid categorical thinking, finds in landscape a fertile concept. Today we see the term revived within Anglophone Geography and widely adopted in such diverse disciplines as architecture, archaeology, anthropology and history, although in Germany the tainted legacy of *Landschaftsgeographie* continues to shadow the reintroduction of aesthetic discourse into geographic study.

[4] Thomas de Costa Kaufmann, *Towards a geography of art* (Chicago: University of Chicago Press, 2004).

[5] Richard Hartshorne, *The nature of geography* (Lancaster, Penn.: Association of American Geographers, 1939) p. 158.

Much has been written about the etymology of the word 'landscape:' how it originated in the Germanic language area as *Landskap* (Swedish) or *Landschaft* (German), how it became attached to a genre of scenery painting by sixteenth and seventeenth-century Dutch artists, thence to be introduced to England as *landskip*: a seventeenth-century pictorial term for the representation of a pleasing 'prospect,' generally associated with landowners celebrating their property aesthetically in painted views, poems or designed parkland.[6] The meaning of the English word *landscape* now extends from framed views of specific sites to the scenic character of whole regions; it applies equally to graphic and textual images as to physical locations. Through all these applications, landscape retains an unshakeable pictorial association, although this is no longer confined to the framed view or to aesthetic pleasure. Only in Geography is there a lingering usage in which the visual is subordinated to the areal aspects of landscape.[7]

From a critical perspective, the pictorial dimension of landscape has been charged with duplicity. In an influential dissection of landscape's capacity to 'naturalize' social or environmental inequities through an aesthetics of visual harmony, Stephen Daniels has drawn upon examples of eighteenth-century English parkland and 'model villages' that present a scene of apparent harmony between a rooted, 'organic' community, its material culture constructed out of local materials, and the physical environment in which it is situated. He points out that many of the 'Georgian' landscapes, so often viewed as paradigms of English social and environmental order, were painstakingly constructed by often rapacious landowners in the course of destroying more communal but less profitable fields, farms and dwellings in order to maximize capital returns.[8] In his ironically titled *Lie of the land*, another geographer, Don Mitchell, has used *landscape* critically, to expose the inequities of capitalist agriculture, migrant labor exploitation and racism hidden below the Edenic images of

[6] The best recent philological discussion of landscape is Kenneth Olwig, *Landscape, nature and the body politic: From Britain's Renaissance to America's New World* (Madison: University of Wisconsin Press, 2002).

[7] Hartshorne, Nature of Geography *op.cit.*, p. 163, discussing the visual aspects of area, states: 'By assuming, as geographers commonly do, that we see the area from above, we eliminate the sky; the atmosphere of the earth is then simply the medium through which we see the solid and liquid forms of the earth surface. We see only, however, the external surface that underlies the atmosphere – formed by the surface of water bodies, the uppermost foliage of the trees in forests, by grass or by top-soil in the bare fields, or by the outer surface of buildings, etc. All of these surfaces together form a continuous surface over the area and it is this surface, and this surface alone (other than the sky) that produces the sensation of the visual landscape in our minds'. He goes on to argue that the geographer does not need to see this surface to know it exists ('a giant could feel it with his hands') and that the important aspects of landscape in geography are the areal ones.

[8] Stephen Daniels, *Humphry Repton: Landscape gardening and the geography of Georgian England* (New Haven & London: Yale University Press, 1999).

California's agricultural scenery, while the literary critic W.J.T. Mitchell has exposed the complicity of landscape visions with colonial exploitation, referring to landscape as 'the dreamwork of empire'.[9]

We are not obliged to reduce landscape so completely to a tool of social conflict in order to recognize that its semantic evolution has been a linguistic expression of complex cultural processes that are historically tied to the social evolution of the modern world. I refer to this as the history of the 'landscape idea,' a characteristically modern way of encountering and representing the external world: in its pictorial and graphic qualities, in its spatiality and ways of connecting the individual to the community, as well as in such forms of representation as maps, paintings, photographs, and movies. I have argued that the roots of the modern landscape idea might be found in the changing landed property relations in early-modern Europe's mercantile urban regions.[10] I want here to draw upon recent landscape scholarship to explore why landscape retains its potency today: enough to shape not only the way I and others actually connect to such a quintessentially modern place as Los Angeles, but to account for many of the forms and patterns that actually exist in Southern California. By demonstrating landscape's conceptual relevance there we may be able to recuperate it finally from the taint of essentialism attached to what Gerhard Hard has called *Hagia Chora*.

My exploration of the links between landscape and modernity is divided into three parts. I open with a discussion of landscape's conceptual role in articulating a response to the characteristically modern question of 'community,' and show how this constituted the original synthesis of the territorial and the pictorial. I then explore ways that landscape's moral authority, located in its pictorial expressions, has been extended spatially to territorializing the imagined community of the nation state. Finally, I discuss how landscape, now thoroughly naturalized as a picturesque expression of utopian social and environmental relations, has played a role in shaping through images a completely modern space such as Southern California, and in so doing has come full circle, generating social spaces that bear remarkable similarities in structure and process, if not in form, to the original and pre-pictorial meaning of *Landschaft*.

[9] Don Mitchell, *The Lie of the land: Migrant workers and the California landscape* (Minneapolis: University of Minnesota Press, 1996); W.J.T. Mitchell, *Landscape and power* (2nd ed., Chicago & London: The University of Chicago Press, 2002). David Blackbourn's *The conquest of nature: water, landscape and the making of modern Germany* (New York & London: W.W. Norton, 2006) was published too late for me to incorporate here his quite brilliant analysis and discussion of the relationships between landscape ideas and practice in Germany since the early 19th century.

[10] Denis Cosgrove, *Social formation and symbolic landscape* (2nd edn., Madison: University of Wisconsin Press, 1998 (1984)).

Landscape and community

Landscape is a connecting term, a *Zusammenhang*. Much of its appeal to modern ecologists, architects, planners and others concerned with society and the design of environments lies in landscape's capacity to combine incommensurate or even dialectically opposed elements: process and form, nature and culture, land and life. Landscape conveys the idea that their combination is – or should be – balanced and harmonious, and that when such harmony exists, it is visible in the geographical patterns of the external world. The metaphysics of balance and harmony slide easily between the aesthetic and the social, so that in landscape the aesthetics of scenery become a moral barometer of a successful community: human, natural or in combination.

As a critical device, this moral argument has been applied in different European societies to both humanized and natural spaces since the late 18th century. Thus the 19th century French social reformer Frederick LePlay's triad of *place, work and folk* was graphically expressed by the Scottish architect, ecologist and regionalist Patrick Geddes as the 'valley section' where human activities arise out of organic connections with the land and express themselves in an evolving series of settlement landscapes [Figure 2].

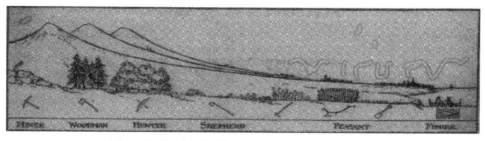

Figure 2 Patrick Geddes: 'The valley section' (1909)

In Germany, the same idea is traceable at least to Johann Gottfried Herder, and was most famously expressed in Martin Heidegger's 'Building, dwelling, thinking,' (a piece in which the old bridge in Heidelberg figures strongly).[11] Mid-twentieth century urban thinkers in both Britain and Germany attached the term 'townscape' (*Stadtlandschaft*) to picturesque visions of the (preindustrial) city as a balanced human community and dwelling place whose social qualities were apparent in the informal but harmonious aggregate of buildings and open spaces. In the USA, by contrast, landscape has more often been applied to 'wilderness' environments, often wholly devoid of human presence (although commonly produced by the active removal of

[11] Martin Heidegger, 'Building, dwelling, thinking', in David Farrell Krell (ed.) *Martin Heidegger: Basic writings from* 'Being and Time' (1927) *to* 'The Task of Thinking' (London: Routledge and Kegan Paul, 1978) pp. 319-340.

human communities), where a balance and harmony of the non-human communities is believed to depend upon the absence of permanent human habitation. What the designation *landscape* brings to all these diverse spaces is the idea that their qualities as dwelling places (biotic, animal, human…) are rendered visible in their pictorial form.

The immediate question that arises from this is precisely how the pictorial form of space came to be so closely tied to ideals of natural and human community. In a meticulous survey of the historical origins of this fusion in northern Europe and its extension to the USA, the Danish geographer, Kenneth Olwig points out that the Germanic *Landschaft* applied originally to quite specific locations in the North Sea and Western Baltic regions. *Landschaft* and its cognates in the Scandinavian languages are still used as a descriptor for administrative regions in parts of Holland, Frisia and Schleswig-Holstein. The physical character of these low-lying marshlands, heaths, and offshore islands is, he believes, important in understanding this usage. These have always been relatively impoverished regions, marginal to the interests of monarchs and aristocrats whose wealth and power depended upon the control, ownership, and taxation of more fertile and accessible territories and mercantile cities. Location on the borderlands of the Danish kingdom and the German states reinforced the opportunities for greater local autonomy than in more central and tightly administered regions. Olwig points out that their designation as *Landschaften* denotes 'a particular notion of polity rather than . . . a territory of a particular size. It could be extrapolated to polities of various dimensions, ranging from tiny Utholm to the whole of northern Jutland.'[12] Critical to their designation as landscapes was that these were regions in which customary law, determined in various ways by the community living and working in an area, extended over and defined the territorial limits of the 'Land'. 'Custom and culture defined a Land, not physical geographical characteristics [nor fixed territorial scale] − it was a social entity that found physical expression in the area under its law.'[13] The unity of fellowship and rights within the community and the physical area over which fellowship and rights held sway, constituted the *Landschaft* [Figure 3]. This understanding of space was expressed by Heidegger in a key passage from 'Building, dwelling, thinking:'

> A space is something that has been made room for, something that is cleared and free, namely, within a boundary, Greek *peras*. A boundary is not that at which something stops, but, as the Greeks recognized, the boundary is that from which something *begins its essential unfolding.* That is why the concept is that of *horismos,* that is the horizon, the boundary. Space is in essence that for which room has been made, that which is let into its bounds. That for which room is made is always granted and hence is joined, that is, gathered by virtue of a location … *Accordingly, spaces receive their being from locations and not from "space".*[14]

[12] Olwig, Landscape, nature and the body politic *op. cit.*, p. 11.

[13] Ibid., p. 12.

[14] Heidegger, 'Building, dwelling, thinking' *op. cit.*, p. 332. Original emphasis.

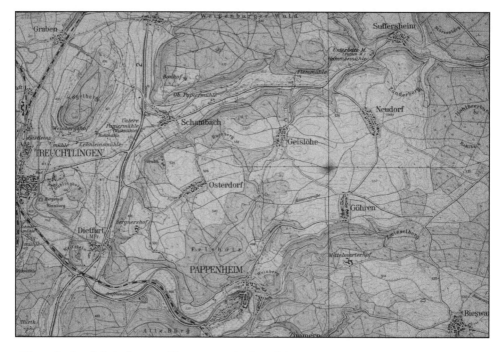

Figure 3 *Landschaft* of street villages, open fields and forest clearance near Pappenheim from a German 1:50,000 topographic map (Topographische Karte 1:50000, © Landesamt für Vermessung und Geoinformation Bayern, 1626/06)

In this respect, the root sense of *Landschaft* finds parallels in most European languages, although the precise legal situation may vary from that to be found along the North Sea coasts. The English word *countryside*, the French *payage*, the Italian *paesaggio* and the Spanish *paisaje* are similarly social, and scale-flexible, denoting a collective relationship with land more than a specifically bounded territory. The common Latin root of the Romance-language expressions, *pagus* (a village or country district) is also the root of *paganus* or 'pagan,' the term urban Christians would apply to those whose deities were located in the physical world as members of the community of dwelling, rather than a metaphysical and distanced creator.

While it is predictable that in a pre-modern, agrarian society, the localized combination of community, custom, and land would give rise to visibly apparent distinctions between individual *Landschaften*, the scenic aspects now so intimately associated with landscape were in no sense primary within the Germanic word and its cognates. The nature of *Landschaft* as originally constituted is of more than antiquarian significance. It points to a particular spatiality in which a geographical area and its material appearance are constituted through social and environmental practice. In a pre-modern world such practices were dominated by production,

whether agricultural, artisanal or industrial. In today's landscapes, they are increasingly dominated by consumption.

Landscape and scenery

The scenic dimension became attached to landscape in the late 16th and early 17th centuries. In a now classic study of the origins of landscape painting, the art historian Ernst Gombrich identified a 1521 Venetian inventory of art works, including Giorgione's *Tempesta*, described as 'a small landscape [*paesetto*], on canvas, with a thunderstorm, a gipsy and a soldier', as the earliest application of 'landscape' to a distinct genre of art.[15] The designation of landscape as a type of painting was first made by Italian connoisseurs, but was applied primarily to Northern European art works. In Gombrich's words 'this demand [for painted landscapes] was a gift presented by the Renaissance South to the Gothic North.'[16] Developing Gombrich's insight, the art historian Svetlana Alpers has identified distinct modes of picturing that existed either side of the Alps: Italian *single point perspective* which emphasized the role of the observer using eye and the rectilinear grid to organize a two-dimensional image of three-dimensional external space, and *projection*, developed in early-modern Flemish and Dutch art, as a method for inscribing objects in a three-dimensional world on the flat surface so that their relations become clear and legible. The latter process she terms 'the mapping impulse.'[17] The social historian Martin Jay has termed these different techniques 'scopic regimes,' connecting them to distinct social and political structures that developed in two of Europe's most dynamic mercantile cities: Florence and Antwerp. Unsurprisingly perhaps, it was in cities where Flemish and Italian influences met and mixed most fully and where map-making, engraving and printing became major industries by 1500 – north east Italy and southern Germany – that schools of landscape paintings first become distinguished, in the works of the Venetian Bellinis, Giorgione and Titian, and the Danube painters Cranach, Patinir and Altdorfer. Albrecht Dürer, a key early practitioner of landscape was intimately familiar with both places.

In Venice, the taste for paintings of landscape paralleled a demand for pastoral poetry, arcadian writing and actual landscape views among patrician families investing heavily in the landed estates that they were improving through drainage, irrigation, new-world crops and new labour practices. The walls of their newly constructed villas were decorated with idyllic *trompe l'oeil* landscapes that harmonized imaginary scenes

[15] E.H. Gombrich, 'The Renaissance theory of art and the rise of landscape', in idem, *Norm and form: Studies in the art of the Renaissance* (London: Phaidon, 1966) pp. 107-121. Quotation on p. 109.

[16] Ibid., p. 110.

[17] Svetlana Alpers, *The Art of describing: Dutch art in the seventeenth century* (Chicago: The University of Chicago Press, 1983).

of ancient Roman villa life with views of the rustic world to be found across their estates.[18] In south German cities such as Augsburg, Ulm and Nuremberg, landscape paintings and engravings reflected rather different commercial and political realities. On the one hand, appropriately in the city of the Fuggers whose capital financed political and commercial schemes of global reach, landscape paintings captured vast – almost global – scenes within tiny, jewel-like frames, often referred to as 'cosmographies.' On the other, as chorographies expressing a desire for local connectedness, the images depicted and celebrated the countryside immediately surrounding the city. It was to these landscape images, and the maps issuing from the same hands and presses, that Dürer was referring when he claimed that 'the measurement of the earth, the waters and the stars has come to be understood through painting.'[19]

Dürer's words capture the difference between the older and newer meanings of landscape: no longer the undifferentiated space of unreflective social dwelling and 'pagan' attachment to land, but earth, sea and stars conceptualized; no longer space regulated through the customary practices of daily life, but 'nature' measured across the surface of paintings and maps. Kenneth Olwig has charted landscape's evolution in early 17th century Britain through the political process whereby the Stuart court sought to unify the newly national territory – the 'country' – under its 'natural' authority derived by divine right and to subordinate more local custom. An element of this was the emerging culture of measured and scenic landscape: apparent in the scenography of courtly theater and masque, in 'prospect' poetry, in projects for mapping the realm, and in the growing demand among landowners for Dutch artists to depict their newly enclosed and surveyed estates. Those artists had honed their skills in the context of Holland's own hard-won independence, and the huge polder reclamation schemes whose technical and social realization depended upon accurate survey, leveling and mapping of the bounded spaces in which urban merchants were investing their capital. In Catholic France, monarchial absolutism as a mode of territorial and economic reorganization found formal and pictorial expression in the vast landscape geometries of Versailles, Fontainebleau and Gentilly. In republican Venice, the culture of landscape connected intimately with the political and economic reorganization of the state.

The terminology and formal expression of landscape's shift to incorporate the graphic and pictorial varied geographically across early modern Europe. But at its many scales, from the estate to the city region to the national state, landscape was consistently reformulated as an 'idea' that bounded and mapped territorialized spaces

[18] Denis Cosgrove, *The Palladian landscape: Geographical change and its cultural representations in sixteenth century Italy* (Leicester: Leicester University Press, 1993).

[19] Christopher S. Wood, *Albrecht Altdorfer and the origins of landscape* (London: Reaktion Books, 1993).

out of former existing *Lande*, *paese*, and *pays*. Consistently too, reformulation involved such mathematical and graphic techniques as perspective, projection, geometry and trigonometry, denoting a distanciated and cognitive rather than an affective, quotidian relationship of land and social life.

The pictorial sense of landscape layered over rather than erased the word's affective sense as a community of locality and life. Indeed, makers of landscape images commonly sought consciously to represent such a supposedly organic relationship as enduring, even as they confined its signifiers to such marginal and decorative items as passing swains and their animals, quaintly rustic cottages and ancient ruins, commonly placing these elements in what John Barrell called 'the dark side of the landscape,'[20] and harmonized the image of land and life through the sophisticated techniques of pictorial composition, color and shadowing that are so apparent in the arcadian canvases of Claude Lorrain and Gaspar Poussin, and in the parkland landscapes of 18th century Britain that were modeled on those Roman painters' works. What the pictorializing of landscape also permitted was a 'scale jump' whereby *Landschaft*'s spatial flexibility could be stretched to accommodate the newly significant idea of modern nationhood.

Landscape and the nation

Collectively, the pictorial techniques developed in early modern Europe for representing landscape came to characterize the aesthetic idea of the *picturesque*. In common speech, picturesque refers to any scene, real or represented, that has the pleasing qualities of a painting. But as an aesthetic category, the picturesque emerged in 18th century English philosophy directly out of landscape discourse, and represents a fusion of aesthetics and moral thinking provoked by modernity's social and spatial disruptions. Defined by a small group of cognoscenti in the mid-1790s, the picturesque sought a mediating term between Edmund Burke's aesthetic and moral binary of the 'sublime' and the 'beautiful.' The picturesque's defining visual characteristics were 'roughness', 'wildness' and 'irregularity', words that, in the context of Romanticism, the French revolution and the Jacobinism then infecting such British Romantics as William Blake, William Wordsworth and Percy Shelley carried powerful social and moral as well as visual significance. The picturesque encapsulated a wide-ranging debate in late Georgian England about the social, political and moral health of a rapidly industrializing and urbanizing nation facing the challenge of a revolutionary and territorially ambitious France. In both countries, historical rivalry was being cast in the essentialist terminology of national difference.

[20] John Barrell, *The dark side of the landscape. The rural poor in English painting 1730-1840* (Cambridge: Cambridge University Press, 1980).

Touching in Britain on such contentious internal matters as enclosure of common lands, removal of village communities for emparkment, and planting fir trees for short-term commercial profit rather than oaks that would provide naval timber generations hence, and even on colonial slavery, the debate over the look of the land involved 'the patriotism of landscape improvement: its allegiance to various geographical identities, local and national, provincial and metropolitan, English and British.'[21] Pictorial, cartographic and parkland landscapes offered a medium through which questions of national identity could be debated in the same Napoleonic years that the modern nation state was being imagined and constructed.

Picturesque landscape rapidly escaped the confines of patrician conversations about park design to become a field of concern for a growing bourgeoisie. *Picturesque* was applied to a style of seeing and representing places that took a nostalgic pleasure in the signs of roughening through age, longevity and decay; a sentiment that we can easily recognize as a response to the cultural uprooting and displacement associated with contemporary industrialization, urbanization and revolutionary political change, in short, to modernization. Not incidentally, the word *nostalgia*, that combines the sense of bodily pain and returning home[22], was coined in these very years as a quasi-medical condition of 'melancholia caused by prolonged absence from one's home or country'.[23] Picturesque landscape images, while easily drained of the explicit social concerns of early theorists, nevertheless sustained the dream of an harmonious, organic connection between a locality and its community, visible in the historical depth of dwelling, but presently under threat, if not already lost to the past. The viewer of such images is of course inescapably positioned *outside* landscape, in a materially and affectively distinct space. From this structurally alienated position, the response to the image cannot be other than sentimental and nostalgic.

Among the greatest masters of picturesque painting was J.M.W. Turner. His oils, watercolors and engravings constructed a sentimental geography of Western Europe: the rivers of France and England, the Rhine gorge and the mountain passes of Switzerland, the Italian lakes, the ruined castles and abbeys of upland Britain. But, if his early images adopted popular picturesque conventions, as his long artistic career progressed, Turner's landscapes became much more critical, probing deeply the complex relationships of past and present and the ambiguities of modernity. Some works explore profound, even pagan attachments of people and place, of the type that Heidegger would have endorsed. Others capture and celebrate the onrush of modern, industrial life and the spatial compression of modern communications.

[21] Daniels, Humphry Repton *op. cit.*, p. 104.

[22] The Greek words are *nostos*, signaling a return to origins (home) and *–algia*, bodily pain or that which gives rise to it.

[23] *Oxford English Dictionary*.

Precisely by refusing the sentimental nostalgia that always attends picturesque landscape, Turner used landscape painting as a powerful medium through which modernity could be explored and its contradictions exposed.

This is what John Ruskin, Turner's most influential admirer and the 19ᵗʰ century's greatest landscape theorist, recognized in the painter's art. Ruskin consistently praised Turner's landscapes for their 'truth.' By this, the critic did not mean their mimetic qualities or representational accuracy, but rather Turner's fidelity to the way the world is, and his capacity to capture without sentiment the appearance of landscape, so that through the details of its morphology – its formal appearance – natural and social processes may be revealed and understood. In Ruskin's writings, the picturesque retained a powerful moral engagement:

> If there be visible pensiveness in the building, as in a ruined abbey, it becomes, or claims to become, beautiful; but the picturesqueness is in the unconscious suffering, the look that an old labourer has, not knowing that there is anything pathetic in his grey hair, and withered arms, and sunburnt breast; and thus there are the two extremes, the consciousness of pathos in the confessed ruin, which may or may not be beautiful, according to the kind of it; and the entire denial of all human calamity and care, in the swept proprieties and neatnesses of English modernism: and, between these, there is the unconscious confession of the facts of distress and decay, in by-words; the world's hard work being gone through all the while, and no pity asked for, nor contempt feared.[24]

Both Turner and Ruskin addressed through landscape the complex moral questions raised by changing social relations in the context of the territorial nation as the modern world's primary community of allegiance. They shared the characteristically Romantic belief that would be so strongly developed within German nationalism that the essential character of the nation as a community was to be found among those most immediately attached to its land: the peasantry. In one of Ruskin's earliest writings, *The poetry of architecture*, whose subtitle 'the architecture of the nations of Europe considered in association with natural scenery and national character' perfectly captures his argument, the young critic's immediate target is the eclectic

[24] John Ruskin, *Modern painters* Vol. IV (London: Smith, Elder & Co., 1856) p. 6. [The full passage is available at http://art-bin.com/art/oruskin1.html]

We might compare Ruskin's words with the passage from Heidegger's 'Building, dwelling, thinking':

Mortals dwell in that they await the divinities as divinities. In hope they hold up to the divinities what is unhoped for. They wait for intimations of their coming and do not mistake the signs of their absence. They do not make their gods for themselves and do not worship idols. In the very depth of misfortune they wait for the weal that has been withdrawn.

Mortals dwell in that they initiate their own nature – their being capable of death as death – into the use and practice of this capacity, so that there may be a good death. To initiate mortals into the nature of death in no way means to make death, as empty Nothing, the goal. Nor does it mean to darken dwelling by blindly striving toward the end.

borrowing of architectural style and decoration to be found in the bourgeois villas and houses of London's spreading suburbs.[25] From a study of rural cottages in regions of England, France, Switzerland and Italy he seeks to derive principles of scenery through which to evaluate harmony between the forms and colour of topography, vegetation and weather on the one hand, and those of human habitation on the other. Examples of true harmonization are to be found, in his opinion, where a peasantry has laboured the land from time immemorial, using materials derived from the immediate locality to produce their dwelling places, maintaining and repairing modest cottages in keeping with tradition. This is an immediately recognizable theme in the critique of modern life, voiced explicitly for example in Heidegger's repeated celebration of the Black Forest *Volksgemeinschaft*. Such communities, in Ruskin's opinion provide the foundations of national identity:

> Man the peasant, is a being of more marked national character, than man, the educated and refined. For nationality is founded, in a great degree, on prejudices and feelings inculcated and aroused in youth, which grow inveterate in the mind as long as its views are confined to the place of its birth; its ideas moulded by the customs of its country, and its conversation limited to a circle composed of individuals of habits and feelings like its own; but which are gradually softened down when the mind is led into general views of things, when it is guided by reflection instead of habit, and has begun to lay aside opinions contracted under the influence of association and prepossession, substituting in their room philosophical deductions from the calm contemplation of the various tempers, and thoughts, and customs, of mankind. The love of its country will remain with undiminished strength in the cultivated mind, but the national modes of thinking will vanish from the disciplined intellect.[26]

It is significant, I think, that Ruskin's explicit target in these early essays was the external appearance of the British suburban house and its relations with the physical geography of its location. The suburb is Modernity's characteristic dwelling space, its most authentic landscape expression, and consequently a focus of intense critical attention.

The idea of landscape was widely used in the construction and communication of 19th and 20th European and colonial nationalism. In every modern nation, specific regional scenery has been generalized, often through the medium of art itself, as iconic of the whole nation. Thus in Britain, a 'home counties' scenery of lowland chalk downs, wide river valleys with slow-flowing perennial streams, compact villages with towered or spired churches set among a hedgerow mosaic of garden-like fields, sometimes with distant views of sea cliffs and bays, leaps scale through the popularity

[25] For a detailed discussion of the close parallels between John Ruskin's thought and the treatment of landscape within cultural geography, see Denis Cosgrove, 'John Ruskin and the geographical imagination', *Geographical Review* 69 (1979) pp. 43-62.

[26] John Ruskin, *The poetry of architecture: or the architecture of the nations of Europe, considered in its association with natural scenery and natural character* [1837] (London: George Allen, 1893) pp. 93-94.

of paintings by John Constable, the pre-Raphaelite Brotherhood and successor artists, to become figured as the whole nation's vulnerable and feminized 'heartland.'

Figure 4 Iconic settlement landscape of whitewashed cottages and dry stone walls in Western Ireland (A. Orme)

The scene is extended to national landscape in the cover images of 1920s topographic maps, then being promoted as leisure guides for ramblers and hikers rather than part of the nation's strategic defence. In Ireland it is the West Coast regions of harsh limestone pastures, dry stone walls, *clachen* hamlets and circular towers that serve as the nation's iconic landscape [Figure 4]; in Italy the hills of Tuscany, in Germany the forest, heath and granite scenery Christianized by Caspar David Friedrich. Nor is this cultural process confined to the West: the two Koreas for example share a common Confucian image of the mountain peaks and torrents of the 'backbone' Paekdusan range constituting a unified national landscape. In each case we can trace the iconic image to the work of a single artist (poet or writer) or a group of artists whose immediate market is metropolitan but whose embrace of a specific regional landscape evokes a spirit of picturesque nostalgia for a harmony of

land and life felt to be passing away with modernization. Always too, while land-form, flora, light and other aspects of physical geography are critical compositional elements, the pictorial landscape must contain evidence of harmonious dwelling, of a paradigmatic national community.

Geographers and landscape

It is a simple and predictable step from promoting the pictorial or scenic qualities of specific landscapes as embodying essential qualities of a nation's territory and people, to seeking to preserve and protect such areas from change.[27] Indeed, precisely because such spaces are deemed to embody natural and immemorial qualities they become patrimony, ever threatened by another fundamental discourse of nationalism: progress and modernization. It is not therefore surprising to find such figures as John Ruskin among the earliest proponents of architectural and landscape conservation in Britain, nor to find newly-independent nations allocating significant amounts of often scarce resources to maintaining not only the physical morphology but also the social form of their iconic landscapes, as Ireland has done in the Irish-speaking *Gaeltacht* regions of the Atlantic West or Estonia is currently doing in the eastern rural region of Tartu and the island of Saaremaa.

Preservation, protection, conservation, sustainability: while each of these parses slightly differently a similar sense of arresting or at least negotiating the impacts of change with the intention of sustaining inherited values, they all reflect the same contradiction of modernity: a belief in improvement and progress generates its opposite in 'tradition,' whose poignancy bespeaks a sense of loss that has often been interpreted as a sign of a more existential alienation. This is a discourse that reaches through virtually every aspect of modern thought, from our approach to the 'threatened' flora and fauna of the natural world, through questions of 'cultural heritage,' to the embrace of selectively constructed ethnic and religious identities and traditions. Landscape is significant within this quintessentially modern discourse precisely because it puts into material form the matter of *dwelling*, to adopt Heidegger's meaning of pulling together earth, sky, the divinities (in the *pagan* sense of the life-sustaining natural elements and forces) and the mortals, individually and collectively.

The foundation and evolution of cultural geography as an intellectual project lie precisely within this modern dilemma. Cultural geographers have used landscape as a

[27] Such actions initially fall under what Svetlana Boym (*The future of nostalgia*, New York: Basic Books, 2002) calls *reflective* nostalgia which emphasizes *–algia*, the bittersweet pain of longing and loss and dwells upon ruins, on the patina of time and history, on uncanny silences and absences, and on dreams. She contrasts this with *restorative* nostalgia; *nostos*, 'rebuilding the lost home and patching the memory gaps.' Of course, landscape conservation today can take both forms.

defining concept, drawing on the foundational meanings of *Landschaft* which they resurrected, but examining landscape through the visible morphology of its natural and human structures, topographic maps, photographs and sketches. In short, they have viewed landscape through the perspective of characteristically modern ways of seeing – through the lens of the landscape idea – in order to confront the dialectics of modernity. In Germany for example, the geographical study of *Kulturlandschaften* cannot be divorced from Wilhelmine concerns with *Volksgemeinschaft* and determining the boundaries of the German *Raum*. The French regional monographs that elaborated Vidal de la Blache's pen portraits of *pays* in his *Tableau de la géographie de la France* were rooted in the representation of regional diversity on 1:100,000 and 1:50,000 topographic map sheets produced by the state's *Institut Géographique Militaire*. In Britain, the most significant work in cultural geography was undertaken at universities in Wales and Ulster, focusing on such questions as the changing distribution of Welsh language speakers and their connections with specific environmental features of upland Britain, while Sir Dudley Stamp's 1930s National Land Use Survey, undertaken in the spirit of Patrick Geddes' beliefs in the balance of 'place, work and folk,' became an instrument of national landscape conservation policy in the era of post-war planning.[28] And even in the USA, Carl Sauer and his students at the University of California basing their cultural geography on German methodology, applied it to landscapes where pre-modern, supposedly stable, folk cultures had worked a mutual harmony between physical and human ecologies. In all cases, the geographers sought in landscape a medium for negotiating, sometimes resisting and sometimes assisting the processes of modernization.

Landscape in Southern California and the dialectics of modernity

It is perhaps ironic that within Anglophone cultural geography, it should be in mid-century California that scholars most fervently embraced the landscape idea as a critique of modernity. With a permanent settlement history of less than two hundred years, lacking any tradition of peasant agriculture, and a 20th century experience of explosive, hypermodern urbanization, accompanied by unprecedented topographic, hydrographic and ecological transformation, California, and especially its southern, semi-desert zone of suburban sprawl, represents for many observers the very antithesis of landscape as a local integration of community life and regional nature, from which nostalgia might construct an iconic image. Indeed, Southern California has consistently been held up by European and East Coast American cultural critics as hypermodernity's paradigm placeless space. The region's historic and geographic

[28] Denis Cosgrove and Simon Rycroft, 'Mapping the modern nation', *History Workshop Journal* 40 (1995) pp. 91-105.

reality is, predictably, more complex than such criticism allows. Indeed, in its very post-modernity, contemporary California may be returning us to something remarkably parallel, if not exactly similar, to the premodern experience from which the landscape idea diverged.

It is not possible to offer here more than a brief synopsis of Southern California's settlement history. None of the bewildering number of linguistically distinct pre-Columbian peoples who occupied the region at the time of Spanish conquest was engaged in permanent agriculture, and as hunter-gatherers their impacts on the land were ecological more than architectural. The Spanish-Mexican *rancho* and mission system that lasted a mere seven decades may be traced today as remnant forms in cadastral and road patterns, in place names, and in the spine of mission, *presidio* and *pueblo* settlements along the *Camino Real*, but it lacked the intensity of occupance necessary to leave a lasting landscape impression. Indeed its most enduring impacts lie in the ways that a mythical *Californio* culture and romantic lifestyle were deployed by late 19th century Anglo boosters to sell Southern California as a 'Mediterranean' arcadia in which their middle-class clients might re-enact a picturesque, old-world elegance.[29] California's warm climate, balmy air, natural beauty, and a leisured life-style were promoted to financially comfortable mid-westerners as an escape from the rigors of Prairie winters, and crowded, smoky, industrial cities with their associated health problems (especially tuberculosis), and from the growing ethnic diversity of eastern cities for a leisurely life in a white, Anglo-Saxon protestant cottage community set among citrus groves against the backdrop of snow-capped Sierras. Competitively cheap rail fares and the exotic landscape images on rail posters and orange boxes played no small role in bringing large numbers of these people and their capital into the Los Angeles basin and surrounding areas. The region was from the start conceived as much as a space of consumption as of production, and a principal object of consumption was the natural landscape itself.[30]

A characteristic settlement form emerged in Southern California during its first period of rapid urbanization between 1880 and 1920. Former *rancho* land grants were subdivided by commercial developers and sold as small-scale communities, often with a distinctive character: Anaheim was a German fruit-growing community, Hollywood a temperance community, Malibu an artist's colony, Pasadena and Riverside were health and retirement communities, Venice a bohemian seaside resort. Each community determined its own property regulations and land-use statutes, often adopting exclusionary tactics to prevent the influx of minority ethnic or religious groups (Blacks, Asians, Jews). However indefensible, these bear some

[29] Dydia DeLyser, *Ramona memories: Tourism and the shaping of southern California* (Minneapolis: Minnesota University Press, 2005).

[30] William Alexander McLung, *Landscapes of desire: Anglo mythologies of Los Angeles* (Berkeley, Los Angeles & London: University of California Press, 2000).

resemblance to the customary practices that once defined the European *Landschaft*. The former *pueblo* of Los Angeles itself was merely the largest commercial center in a vast zone of distinct settlement communities that sprang up in the mountain foothills and basins of Southern California. Even today, Los Angeles County contains 88 distinct cities, a trace in the political landscape of its initial settlement form.

Planned and developed in the final decades of the 19th century and the first of the twentieth, the morphology of early Southern California settlements reflects then current ideas of the model community, which drew heavily on romantic and picturesque precedents. Ebenezer Howard's hugely influential *Tomorrow, a peaceful path to real reform*, published in 1898 and 1902, is but the most influential of a number of tracts offering a solution in a union of city and country to the perceived disharmonies of industrial urbanization, rural poverty and flight from the land. The 'garden city' was to be a self-governing municipality of no more than 30,000 people, designed with large areas of open space, great boulevards, clearly zoned land uses and residences individually set in gardens. Domestic architecture would draw on the spirit and form of the 'arts and crafts' movement, itself a nostalgic, anti-modern style that used natural materials and non-industrial, craft labor practices, of which John Ruskin was an enthusiastic advocate. The impact of these movements on the generally well-educated, monied and often self-consciously progressive settlers of Southern California is readily apparent in the region's 'craftsman' style of houses set on large lots, the wide, tree-lined boulevards and early introduction of zoning ordinances to control 'non-conforming' land uses.[31]

Early 20th century Southern California's bucolic Anglo settlement landscape is still visible in the vestigial forms of aging craftsman houses, boulevard names and weed-ridden rights of way indicating former tramway tracks, although something of its original form can be seen on the margins of the expanded metropolis. The early, widespread ownership and use of automobiles allowed communities to expand well beyond the spatial constraints imposed by the light rail system, and lined the boulevards with the 'other-directed' architecture of the American 'strip:' gas stations, motels, drive-in restaurants and billboards. This was a truly modern landscape of consumption, designed to be viewed and experienced kinetically and serially, from the windscreen of a moving car. At the same time, the car opened up a more extensive region of mountains, deserts and forests to leisure hungry Southern Californians. Parkways and highways were constructed with the principal goal of servicing the consumption of landscape and scenery. Wartime industrialization and the post-war population boom would see the orange groves, nut orchards and bean fields that surrounded the original settlements subdivided for planned communities,

[31] The earliest zoning ordinances in the United States were passed in California, although their principal intent was to exclude non-white property owners rather than non-conforming industrial uses.

constructed of standard bungalows in the 'modern' style, on restricted garden lots to be sure, but with picture windows designed to bring the external scene into domestic space. Lakewood, for example, a development of 17,500 homes, was constructed on former lima bean fields between Long Beach and Los Angeles over the course of a mere 33 months between 1952 and 1954 [Figure 5]. Individually indistinguishable in the urban field today except by their signed designation on the roadside or on the political map, and overlain with the markers of very different ethnic and cultural groups from their original residents, these communities nevertheless retain traces of the social and scenic ideals that the modern suburb owes to the picturesque tradition of landscape as it was realized in the auto age.

Figure 5 Post-war suburban development in the Los Angeles basin.
Tract houses at Lakewood 1950 (Spence Air Photo collection.
Courtesy: Department of Geography, UCLA)

It was at the extreme edges of the Los Angeles metropolis, in the desert and oasis settlements of the Coachella Valley that at mid-century the landscape idea worked to define the elements of a settlement form that now characterizes 21st century urban neighborhoods across much of the world. In the late 1940s a group of screen actors and movie industry associates, attracted to Palm Springs in its heyday as a relaxed

vacation spot within easy automobile reach of Hollywood, purchased the Thunderbird Ranch for development as a country club, and initiated a novel way of financing their venture. The golf course that lay at the core of the development would be paid for by the sale of residential lots marked out along its fairways and around the greens [Figure 6]. House design would be restricted to single story, low, rambling units (the 'ranch house' style), while a homeowners' association enforced deed restrictions governing the maintenance and appearance of the visible spaces of the community, both private and 'public.' The entire development was gated to exclude all but residents and guests, while the golf course, green with imported fescue and watered from deep desert wells, was the focus of its 'civic' life.

Figure 6 The original golf-course suburb: Thunderbird Country Club,
Rancho Mirage, California, 1959 (Spence Air Photo collection.
Courtesy: Department of Geography, UCLA)

Air conditioning and fast freeways to Los Angeles meant that the recreational home in the desert could become a permanent family residence. Partly through the national televising of golf tournaments played at Palm Springs, the Thunderbird

Ranch came by the late 1960s to represent a leisured lifestyle option promoted and desired across America.[32]

Landscape in all its various meanings and representations is the defining feature of the deed-restricted, gated golf-course suburb that, from its Palm Springs origins has evolved over the past three decades into the dominant form of exurban community in North America and across many parts of Asia and the Pacific Rim. In the pictorial and picturesque sense of landscape, the golf course whose form controls the overall settlement plan, and whose originating geographical morphology was the turf-covered glacial dunes, or 'links' of the Scottish east coast, has become the anodyne successor of 18th century English picturesque parkland, with its combination of gentle grassy slopes, serpentine pathways, copses and 'rough' land edges. The house design of the golf-course suburb emphasizes the large plate-glass 'picture' window, carefully oriented to offer pleasing views over the greens or 'natural' scenery beyond. The scenic sense of landscape is thus the design *Leitmotif* to this form of settlement. The second sense of landscape, as an 'idea,' which so powerfully shaped early Anglo settlement in Southern California, continues in this contemporary materialization of the dream of community, realized in pleasing physical surroundings. Finally, landscape as a harmonious balance of nature and culture shapes the settlement's design language, if not its environmental practices. Although the verdant rolling hills, sandy bunkers and 'rough' of the golf course are almost always engineered spaces, generally quite alien to the natural environment in which they appear and often requiring vast outlays of resources to maintain, and while the residential architecture has become standardized and disconnected from local climate, topography and tradition more fully than John Ruskin could have feared, the formal illusion of leisured consumption is carefully inscribed in all visible features of these spaces.

Conclusion

It is easy to criticize the exurban, gated community, with its exclusionary deed restrictions, 'master-planned' picturesque design conceits and contingent connections with the history and physical geography of its location as the paradigm post-modern space: inauthentic and placeless, an unhomely, pastiche landscape that utterly fails to pull together earth, sky, the divinities and other humans into true dwelling. But it is more accurate to see it as an expression of *restorative* nostalgia, emphasizing *nostos*, the return to home, rather than conservation's reflective *–algia*. And if we are willing to

[32] Lawrence Culver, 'The island, the oasis, and the city: Santa Catalina, Palm Springs, Los Angeles, and southern California's shaping of American life and leisure' (Unpublished PhD dissertation, UCLA, 2004) pp. 288-291.

take a more measured look at these residential consumption spaces, they betray some noteworthy parallels with the original *Landschaften* from which the pictorial sense of landscape diverged. They are a distinct form of contemporary polity: self-regulating communities, politically independent from the major cities to which they are functionally attached, raising their own revenues for such public services as police, waste disposal, education, health and welfare, and developing customary local laws to regulate land uses and appearance. Land is a dominating concern in their community life, although its products are capital value and amenity rather than subsistence. As in Olwig's designation of *Landschaft* quoted above, the exurban community is 'a social entity that [finds] physical expression in the area under its law.' Significantly, they have developed during the same decades that the social welfare character of the modern state has eroded, and its public revenues and moral authority weakened, and they are located at the fringes of regulated metropolitan space. In medieval Frisia, *Landschaften* developed as the spatial expression of communities formed by production; today's deed restricted, exurban landscapes develop out of consumption, the driving force of the 21st century economy.[33] The ethnic homogeneity, so strongly promoted within the modernist state, is also dissolving, and nowhere more rapidly than in Southern California, so that the grip of nostalgia for a pre-modern autochthonous peasantry as the foundation for culture and its material expressions, including landscape is distinctly weakened.

It appears that we have come full circle. A defining historical feature of modernity, as Howard, Ruskin and other social critics recognized, has been rural depopulation and the destruction of *Landschaften*. Karl Marx saw modernity as the capture of the countryside by the city, and following Marx's hint, Henri Lefebvre claimed that 'urbanization completes society.'[34] In the USA, Western Europe and some other parts of the world this process has reached a point where 'city', 'country' and 'urbanization' are of decreasing analytic value. 'Suburb,' an arcadian middle space of dwelling, is the authentic spatial expression of modern consumption, as early 19th century observers like Repton, Loudon and Ruskin anticipated. And, through the visual language of the picturesque, landscape is the geographical expression of the suburb as consumption space. If such landscape is duplicitous, it is less through obscuring the realities of production, for these have been displaced to other spaces, today often half a world away, than in masking a scale and rapacity of material consumption that threatens the sustainability of physical and bio-geographies and thus of dwelling.

[33] Private consumption today accounts for over 75% of US GDP.

[34] Henri Lefebvre, *La revolution urbaine* (Paris: Gallimard, 1970) p. 1.

When I take my evening walk therefore, what I see spread before me is more than a visual icon of 20th century hypermodernity. The Los Angeles basin represents a stage in the complex and historically extended evolution of cultural transformation in which visions of social order and homeliness, and ideals of harmony between land and human life become instantiated in the material forms of landscape. Cultural dismissal of these spaces is a conservative and reactionary response. Better, is to embrace the ambiguities embedded in landscape – as both dwelling and picture – and, as geographers, to seek ways of understanding and engaging with its varied and always rich meanings.

REGIONAL ART: TRANSPENNINE GEOGRAPHY REMEMBERED AND EXHIBITED

Regional art: Transpennine geography remembered and exhibited

DENIS COSGROVE

Place specific art, which aims to connect creative works to the places where they are made or exhibited, and to explore the meanings of place through artistic projects currently offers a powerful point of convergence for a diverse range of interests: commercial, concerned with economic regeneration and development, heritage and tourism; socio-political, concerned with social protest, developing identity, bringing disparate social groups together, or articulating unheard voices; and artistic, concerned to break the conventions of the gallery and present art to a larger, more demotic audience, to challenge conventional representational forms of art in public space, and to explore the nature of individual places. Place specific art, consciously aiming to reinforce or transform place meaning has thus enjoyed considerable patronage over the past two decades, primarily in cities but also in rural regions across the world. The phenomenon raises complex theoretical as well as practical questions.[1]

In this essay I comment upon some of the geographical issues raised by site-specific art through reflections on a 1998 British project titled *Artranspennine* that involved thirty individual artists and artistic groups who were invited by the Henry Moore Institute in Leeds and the Tate Gallery of the North in Liverpool to undertake projects that in some way articulated or expressed the idea of a trans-Pennine region: a distinctive part of Northern England stretching from the River Mersey to the Humber estuary and including the counties of Lancashire, Cheshire, Derbyshire and Yorkshire. The initiative was funded by the Regional Development Fund of the European Union with the declared aim of exploring 'the richness of the region through the creativity of contemporary art' and helping 'to forge a cultural identity and exemplify and project the quality and diversity of our region to resident communities and visitors'. The thirty projects were exhibited or performed across the region during the year and documented in the book *Leaving tracks*.[2] I organize my comments on art and regional space around three themes that arise out of the goals of the exhibition, and list them under the headings: geography, memory and exhibition. I write on the first as a professional geographer; on the second as a native,

[1] Perhaps the best theoretical discussion of this phenomenon is Miwon Kwon, *One place after another: Site specific art and locational identity* (Cambridge, Mass. & London: MIT Press, 2004).

[2] The project and its various artistic productions are documented in Nick Barley (ed.) *Leaving tracks: Artranspennine 98 – An international contemporary visual art exhibition recorded* (Manchester: August Media, 1999).

born in the transpennine region and now a member of what I shall call the 'transpennine diaspora'; on the third as a student of that particular expression of the art of landscape, mapping.[3]

In preparing this piece, which was originally delivered as a talk to a conference organized to reflect upon the successes and failures of the exhibition, I took a Sunday car trip in late summer 2001 through the region, crossing the Pennine Hills from Hull docks to the banks of the River Mersey in Liverpool, and back. In doing so I was retracing after a thirty-five year hiatus an annual childhood summer journey that my family took regularly between 1953-1968 from our home in Liverpool to visit my grandmother in Grimsby on the south bank of the Humber. Many of these journeys were done in a rented Morris Minor crowded with two adults and three or four children, although the earliest were by steam train or bus over the Woodhead Pass. Later, as a teenager, I followed the same route on an overnight hitch-hike, and in 1968, during summer vacation from university, on a Honda 50cc motorbike. The 2001 trip was both intensely familiar and invoked powerful memories of long-past transpennine times, places and landscapes. During it, I took a series of some forty snapshots, to act as a personal theatre of memory and to be projected, without commentary, as I gave the talk in Manchester. A few of these images are reproduced here, without captions, and are intended to serve a similar function to the slide show at the talk: a silent commentary on place, region and personal memory.

Geography

The declared goal of *Artranspennine* was to make the region itself a gallery for contemporary artworks, for geography to act as the framing and, to an extent, the subject, of an art exhibition. The immediate question raised by such a project concerns the meaning and use of that awkward geographical concept: *region*. What is this transpennine region? How is it – or any region today – to be defined? And how are places and people within such a region to be conceived as a coherent object of discourse and space of operation? These are geographical questions that have long taxed professional geographers. In the past, geographical debates on the regional concept focused principally on questions of scale and boundary and the 'naturalness' of the region as a physical and social, territorial expression. Indeed, my 1968 Honda 50 journey across the Pennines was for the purpose of writing an undergraduate geography dissertation: the required 'regional description' in which connections between the physical and human geographies of a specifically delimited 150 square-mile region had to be described and synthesized. But the focus on boundaries of

[3] I discuss the scope and implications of the term mapping (as opposed to cartography) in my introduction to *Mappings* (London: Reaktion, 1999).

'natural' regions still present in undergraduate geography of the 1960s has long disappeared in geography, and the regional concept largely been abandoned precisely because it seems to express too fixed and inflexible a territoriality, insufficiently attentive to the relativity of lived space and to the dialectics of geographical space and its representation. In seeking to give voice to a delimited regional identity however, the goals of *Artranspennine* re-work traditional concerns of scale and boundary while responding to explicitly contemporary forms of de-territorialization and re-territorialization.

Conventionally conceived, a region is different from a city or a political territory, not merely in form and function, but in our capacity to conceptualize and represent it symbolically or artistically. Even a large and varied metropolis can often be captured by an individual icon, reproducible as a marker in public space, while nation states and their political subdivisions boast an array of flags, coats of arms, iconic landforms and other metonymic devices that occur or are made visible in material spaces. Thus, the Tate Modern art gallery in London literally frames in one of its principal galleries a set-piece view of the Thames, St Paul's Cathedral and the City. London is an extraordinarily complex urban place, to be sure, but by this device of a postcard metonym the metropolis is embraced and connected to images and artifacts inside the gallery – an installation on 'money' for instance, that works ironically against the view of the city's financial centre. Again, however banal the concept, Los Angeles' 300 life-sized winged angel sculptures scattered across the city in the year 2000 and painted as various bizarre characters brought 'the City of Angels' metaphorically to life. Both projects worked with familiar names and very public identities, and they spoke unambiguously to local and visitor alike. Few 'regions' allow such iconic capture.

Transpennine certainly is not conceived as such a unity, either by its inhabitants or by those who visit it, although in area, population and interlock of urban-industrial space, wild upland and sea it is actually rather comparable to the Los Angeles metropolis. Indeed, my drive from Liverpool to Hull in 2001, for which I was accompanied by a fellow geographer who lives and works 'transpennine', demonstrated that transpennine space increasingly looks and performs as a 'post-urban', 'diffused city,' of which Los Angeles is the prototype. The area between the Humber and the Mersey, 150 miles east to west and some 60 miles north to south, exemplifies an increasingly recognized contemporary geographical phenomenon, the polycentred urbanized region. Other examples include the Italian 'citta diffusa' of Lombardy or the central Veneto, the Dutch Randstad and the Ruhr cities of Nordrhein-Westfalen. These are constellations of formerly independent cities and towns, traditionally engaged in mineral extraction or Fordist manufacturing industry but now post-industrial in economy, whose residential density gradients have flatted out into suburbs that today coalesce at points, leaving interstitial zones of exurban

space now farmed more to maintain the appearance of rurality than for a commercially viable agricultural livelihoods. These regions operate in a post-industrial context of information economy, rapid communication corridors, globalized external linkages, rural spaces managed mainly for recreation and heritage, and de-territorialized community attachments. An increasing number of Transpennine's residents treat individual locations such as Manchester, Sheffield, Wigan and Bradford as points of consumer choice across a surface of high and continuous mobility, rather than centres of deep and permanent place attachment. A weekend may involve attending a football match or club in the first of these places, shopping in the second, visiting relatives in the third, before returning to work on Monday in the fourth. But this fluidity is still true for only a minority, and their activity space may as easily include extra-Pennine locations such as Nottingham, Newcastle, Snowdonia, and almost certainly London. Regional attachment if it exists at all, is to a vaguely defined imaginative space perhaps called 'the North' and conceived largely in opposition to the metropolitan spaces of 'the South'.

Labeling such a space a 'region' is in no small measure a product of external forces and as such is a phenomenon characteristic of contemporary Europe, tightly connected to the changing geopolitical realities of European Union and its patterns of planned intervention in economic development. Only an institution of such hubris as the EU could conceive of the M62/E20 Limerick-Petersburg 'corridor' as a single development axis! The example should indicate caution in the face of such bureaucratically defined 'regions,' and their capacity to map either the material or imagined geographies of daily life. It is worth recording that Transpennine has witnessed the imposition of similar conceptual 'regions' as actual administrative entities in the past: the late and seemingly unlamented 'Humberside' County was built out of early 1970s regional planning. The new concept of a transpennine region has similarly complex and at times contradictory historical and geographical foundations.

The regional name 'Transpennine' itself speaks to complex ways that material and imagined geographies connect, and fail to do so. The Pennine Hills are themselves a cartographic conceit dating from an 18th century culture of landscape wherein Classical Italy was mapped onto England (at the same time the Duke of Devonshire collected Claudian landscapes and reshaped his Derbyshire valley at Chatsworth to resemble visions of the Roman Campagna). They are the anglicized *Apennini*, an outsider's conception of geographic unity that bore little relation to either geology or local patterns of land and life. Only from above or beyond the local can the Pennine Hills be conceived as a continuous 'backbone' within national space. Lancashire and Yorkshire, the two principal transpennine counties, were long sustained by quite different agricultural and industrial economies that gave rise to distinct cultures. Within these rival shires, the 'local' has always served to undermine a notion of transpennine. The bearings of the Lancashire and Yorkshire port cities of Liverpool

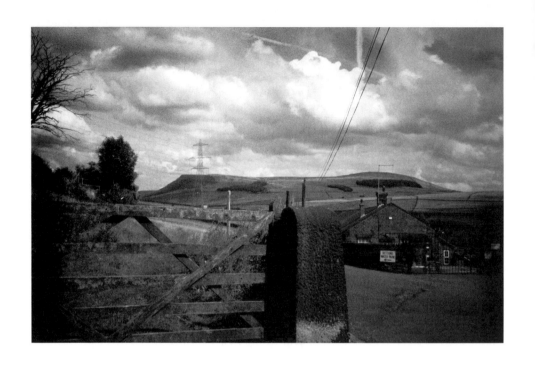

60

and Hull: west & east, Atlantic and North Sea respectively, represent a distinct spatiality unrelated to their agrarian and industrial hinterlands. Liverpool certainly, and to a lesser degree Hull, were never 'Lancashire' or 'Yorkshire' in identity and culture. They were distinctive places, whose vision was directed outwards across the surface of ocean and sea.

'Transpennine', like Pennines, arguably represents the cartographic perspective of an outsider. As the geographer Michael Hibbert comments: 'Flying over the Vale of York on a clear night, the five bare miles of moorland over Blackstone Edge are lost in an extraordinary constellation of street and vehicle lights that stretches all the way to the Irish Sea, with the M62 Hull-Liverpool motorway as its spinal chord.'[4] Hibbert's own analysis of regional geographies of Britain that have been written over the course of the 20th century reveals consistent use of the Pennine edge as a regional divider rather than unifier. And his analysis of traffic flows, phone calls and other indices of communication similarly confirms that 'the [transpennine] corridor is revealed as a pair of back-to-back activity systems, separated by the party wall of the Pennine chain.' However, Hibbert's focus is on functional measures of a region's material geography, and the geographies he cites depended on traditional categories of absolute space, rooted in physiography and contained by physical boundaries, seeking to demonstrate the significance of those boundaries for constructing regionalism in the social world. Cultural geographers today are more concerned with the relative space of imaginative geographies and the ways that space and identity are mutually constituted. This may bring them closer to the conceptual goals and achievements of the *Artranspennine* artists.

Regions in the 21st century are best seen as complex constellations of interactions and transactions, flexible in scale from the local to the global, rarely and only briefly stable over historical time, but which draw equally upon material and imaginative resources and find material and imaginative expressions in landscape. Defining Transpennine along the M62 motorway corridor emphasizes this mobile, de-territorialized aspect by focusing on movements both within and beyond a bounded geographical area. The corridor is more than a single linear feature. It is a network of road, rail, and airports that allows many of its citizens to organize their lives according to a highly selective and flexible use of geographically scattered resources (residential choice, shopping, entertainment, sport, outdoor activity). My childhood trips between Liverpool and Grimsby took the best part of a day (for a child six hours of driving is indeed a whole day...), but by the 1980s fast highway connections made the trip possible in no more than two hours, and the notorious 'Yorkshire Ripper' serial killer exploited the motorway infrastructure to spread fear across the

[4] Michael Hibbert, 'Transpennine: imaginative geographies of an interregional corridor', *Transactions, Institute of British Geographers* 25 (2000) pp. 379-394; quotations on p. 379, 386.

whole region and to escape detection and arrest for nearly a decade. Transpennine's population mass long matched that of the London metropolitan region, but in the industrial era lacked both the integration and the economic conditions to compete as a single entity with the capital. The post-industrial, consumer economy has shifted the balance somewhat: Transpennine now boasts a major international airport at Manchester, together with cultural, educational and sporting institutions as well as retail spaces that negate the need for its residents to look towards London.

This mobile and de-territorialized regional character is actually not without precedent. As Doreen Massey (a fiercely proud Manchester native) has insisted, places are always the local distillation of global processes.[5] Transpennine has deep and long-standing international connections, and not only through Liverpool's imperial and colonial trade with Asia, Africa and the Americas or Hull's fish and timber trade with the Baltic. A principal source of revenue for the 19th century Hull-Liverpool railway from the time of its construction were German, Russian, Polish and Ukrainian economic migrants and political refugees en route to America. Between 1836 and 1914, three of the five million East European and Scandinavian emigrants departing Europe for the USA passed through Britain, and of these full 60% traveled across the Pennine Hills between Hull and Liverpool. It is calculated that eight percent of total European-American migration passed through Hull. Each year between 1865 and 1914 an average of one quarter million continental Europeans went transpennine on the four to five hour rail trip.

Mobility and external connection have left marks not only in the material landscape (in the form of port facilities and buildings, mining and textile structures), but in the living landscapes of today's Asian-, Irish-, and Caribbean-British communities whose members and activities characterize the townscapes of Bradford or Bolton and Leeds for example, and whose imagined geographies connect these cities to towns and villages in Bangladesh, Ireland and Jamaica. An equally significant feature is what I have already referred to as the transpennine diaspora. This has always been a region of movement and migration, as I have indicated in the example of 19th century emigration flows. We might equally take Liverpool's radical population loss in the last four decades of the last century. Of my own family of six children born between 1947 and 1963, no single member lives in the region today. But each retains various degrees of attachment and memories that carry Transpennine as a landscape of memory to locations on two continents. This is not just a question of multi-culturalism or nostalgia, but rather a reminder of the impossibility of a container view of any region today, and of seeking specific scales for cultural meaning or identity.

[5] Doreen Massey, *Power-geometries and the politics of space-time* (Heidelberg: Department of Geography, University of Heidelberg, 1999).

Memory

The mutual constitution of memory and place has been one of the key themes of cultural study for the past decade. Stimulated by such texts such as David Lowenthal's *Past is a foreign country* and Pierre Nora's *Lieux de memoire*,[6] we recognize place as sites where the past leaves intense traces that shape present geographies, constantly seeping into the now, the ghosts of place insistently producing, engaging and disrupting place identity. The past is always *located*, and place is always in important respects a product of memory work. Our personal memories are constituted in large measure through the places we have known; we remember events because they have 'taken place'. Our autobiographies are constructed through places, which is why the diasporic aspects of a region are so vital for its own identity formations. Diaspora connects places and regions across both time and space, reaching beyond the local to locations across the globe, within dense webs of personal memories.[7]

Collective memory also works with and through places, but its relationships are necessarily more contested, more political. Collective or social memory has to be materialized and performed publicly if it is to be sustained. It is expressed and communicated through cultural productions: songs and stories, rituals, parades and performances, monuments and memorials. Narratives may be 'once upon a time', but memorials and monuments are geographically located as material reminders. In both cases, meanings are always subject to renegotiation, for memory is active and labile, ever resistant to our attempts to fix and stabilize its content and significance. And, just as there exist disputes over whether the stories we tell of the past constitute myth or history, place contains and instantiates diverse and often conflicting memories. Characteristically, locating one group's memory and registering it in place, dislocates that of another. *Lieux de memoire* are typically sites of struggle.

Once we move beyond the spaces of specific site to a wider scale, place gives way to landscape, but the significance of memory in shaping meanings does not diminish. Landscape is an especially powerful field of memory because of its ability to naturalize contents and meanings, as the various stories in Simon Schama's *Landscape and memory* so clearly illustrate.[8] For landscape's primary embodiment is in the natural world: in geology, climate and light, soils and vegetation. The cycle of life – birth, death and rebirth – that characterizes nature provides a powerful dimension to landscapes as

[6] David Lowenthal, *The past is a foreign country* (Cambridge: Cambridge University Press, 1985); Nora's work is translated as Pierre Nora, *Realms of memory: Rethinking the French past*, 3 vols. (New York: Columbia University Press, 1996–98).

[7] A particularly apposite discussion of these themes (both personally and academically) is Stephen Daniels' paper 'Suburban pastoral: *Strawberry Fields forever* and Sixties memory', *Cultural Geographies* 13 (2006) pp. 28-54.

[8] Simon Schama, *Landscape and memory* (New York: Alfred Knopf, 1995).

lieux de memoire. Landscapes live through their inhabiting spirits: their *genii loci*, that speak powerfully of grounded (even buried) identities, even as they might project diverse voices into the present. When landscapes witness rapid and radical transformation, as have the transpennine landscapes over the past four decades, their ghosts seem unquiet and the *genius loci* disturbed, the collective memory clouded and contentious. It is in these circumstances perhaps that asking the artist to intervene, in the manner of the *Artranspennine* project seems appropriate.

Rather than ask whose histories, whose memories and what genius of place should be articulated in geographically located artists' work, questions that can never be finally settled, it may be more productive to frame an enquiry into the relations between creativity, memory and place around some of the spatialities I have been considering in this discussion of the geography of Transpennine. A geography of surface, of movement and of contingency signals caution about notions of 'depth', 'rootedness' or 'longevity' and the monumentalizing of memory in landscape, and suggests more fluid notions of memory: in movement, provisionality and connection. The *Artranspennine* project properly avoided the temptation to fix memory and meaning in its regional exhibition of art works by inviting artists on the merit of their previous work and proposals, rather than any 'roots' or 'ties' connecting them to the area, and by asking them to respond to the spirit of the region as they experienced it today. In this sense the project offers a model for dealing creatively with collective memory just as it offers one for handling regional geography. Thus, perhaps surprisingly for a geographer and map lover, I find Anya Gallaccio's *Two Sisters*, a project that involved twin columns of salt placed in the Humber River and gradually dissolving into the water over a period of days, a more satisfying mapping of memory and place than the American eco-artists Helen Mayer Harrison and Newton Harrison's explicitly cartographic *Casting a Green Net: Can It Be We Are Seeing A Dragon?* that used various land use data to inscribe a set of five dragon-shaped maps emphasizing the open space at the heart of the corridor between Mersey and Humber. The two projects seem to represent quite opposing understandings of landscape. The former engaged directly with the material intensities of nature, site and memory without losing its conceptual edge, the latter seemed more purely cognitive and disassociated from memory and the genius of place, driven principally by environmental ideology and thus distanciated in exactly the way that any cartographic project risks becoming.

Such tensions between the ways that art works respond to location and contribute to 'memory work' are entirely proper. The works themselves constitute and create imaginative geographies, and the very fact of their siting beyond the gallery serves to generate further such geographies – experienced, imagined, performed, remembered – geographies that connect Transpennine with its varied and fractured pasts. Their very autonomy as art works theoretically opens them to all the 'stakeholders' in the

region, not seeking to tell sectional histories, but to activate memory at specific sites and make connections within and beyond the region that served as their gallery. Regional space here acts at once as container and exhibition space of the art works and the subject to be 'revealed' by them.

Exhibition

Artranspennine was quite explicitly an *exhibition*. The ruling metaphors – perhaps better, conceits – of the project were of the region itself as a gallery, and, reciprocally, of the artworks 'revealing' or exhibiting the region. To take the former, we know that the gallery is a very specific kind of space. Not only does it provide an 'aura' for the art object (with all the positive and negative implications of that for artist and viewer), but it also serves to label, classify and contextualize the works it contains, to alter the charge of their meanings by the simple fact of location. The wall upon which a painting is hung, its light, colour, height, framing and juxtaposition with other works; the area of floor space devoted to an installation and the ambient materials, light and sound, all serve as spatial determinants of the work's experience and meaning. The creativity and skill of the curator lies precisely in the ability to manipulate these aspects of exhibition. What does this significance of spatiality imply for the idea of public space or region as gallery?

At the scale of specific sites this is not a new question. It is a commonplace of art in public space that it seeks to draw upon, challenge, transform or in some other respect engage the location in which it is placed. Success in this will depend in part on quite specific works and places, and cannot be generalized. There is a substantial body of analytical and theoretical work on public art works, stimulated by artists' own attempts to subvert conventional monumental forms. More interesting perhaps is the impact of the artwork on the meaning and experience of place itself. I am not simply thinking of public response (which is well documented for many of the works in *Artranspennine*: for example the fierce polemic generated by Taro Chiezo's *Super Lamb Banana* located near Liverpool's Pierhead, or the popularity of Joseph Beuys' *7000 Eichen*), but in terms of remaking the spaces and spatialities of the art work's location. I did not personally see Taro Chiezo's work, but I am intrigued by the project's concept. I spent a part of my 2001 transpennine odyssey at the Mersey Tunnel ventilating shaft where Chiezo's yellow, extruded plastic, lamb/banana had been placed. That specific location has powerful personal resonances; my father pointed out the imposing 1930s structure from the Overhead Railway on a memorable last journey before that venerable transit line was demolished; as a child I was awed by the idea that so much air could be drawn down the ventilating shaft into a tunnel far below the estuary; and as an embarrassed adolescent I recall walking past its white stone in an ill-fitting Sea Cadet uniform. The shaft is also a piece of high design,

architecturally a monument set within a space whose form, materials and iconography gestures across the old North Atlantic liner route to the Rockefeller Center in New York, and across the decades to Mussolini's square at the Augusteo in Rome. Public art connects to larger spaces than site alone. I remain captured by the idea of a yellow, plastic sculpture standing in this severe Art Deco space, resonating vaguely with the Beatles' *Yellow Submarine* and Pop images from 1960s Liverpool. Taro Chiezo's banana lamb's now absent presence continues to work at some level, causing me for one, to re-experience and re-think the space.

But there is another aspect to this theme of the region as gallery for exhibition. This concerns the movement of people, those who experienced the art works. The passage of people through a gallery exhibition and how far this is to be determined are important issues for curators. To make a banal comparison: are we to be in IKEA or Marks and Spencer: to moving through the exhibition in predetermined ways or remain free to place ourselves selectively before any object that captures our attention. Making a region the size of Transpennine into a gallery throws a different light on such questions. *Leaving Tracks*, a project that involved items deposited at various commercial locations across the region, to be viewed by means of a journey through it, confronted this issue largely in terms of logistics and the art works themselves: the problems people experienced in seeing all the works within a limited time, taking into account opening hours etc, the impacts of the journey itself on experiencing them. I want to consider two other aspects of movement, more directly related to the idea of the region as gallery.

The first is how different journeys through the works might exhibit different 'regions', different Transpennines. This is a function of both the order of viewing of the art works themselves and of the geographical connections made between them: route taken, mode of transport, time of day, weather. All these aspects are far less within the control of the exhibitor than in the case of a gallery, yet they are critical to the concept of region as gallery. The second matter is the need to recognize that such a project of region as gallery is only even conceivable in the context of the kind of mobility surface I referred to above. The exhibition depended upon and precisely mirrored the condition of consumer flexibility that allows, for example Beverley residents to support Manchester United at a game in Leeds, and a Preston family to take a weekend break in Bruges, via Hull. Region as gallery is region as consumer space.

This brings me to my final comments, which relate to the idea of exhibiting the region itself, geographically at once the most interesting and the most difficult of all the issues raised by a project such as *Artranspennine*. There is precedent for artwork exhibiting a geographic region: it is the atlas. The first modern atlases date from the late 16th century — the time of Shakespeare. Like galleries of maps dating from the same period, atlases were conceived as elaborate and often lavish cultural projects,

not with the intention of way-finding or geographical education, but of celebrating the beauty, wealth and pride of the globe or specific areas of it, by drawing on the reports of navigators' discoveries and on sophisticated artistic techniques. Atlases were objects of luxury consumption that offered the impression of flying high above the earth and seeing the logic and order of geographical space, marveling at its majesty and variety, or at the strange and novel sights offered by places and peoples. The 'chorographic,' or 'regional' maps that made up the atlas combined systematic survey with elevated views of picturesque landscape and often elaborate textual descriptions.

By placing individual maps within a greater collection of precious wonders, an atlas or 'cosmography' (cosmographers were conscious of the etymology of cosmos as 'jewel'), a mobile gallery of geographical regions at different scales could be produced. The first atlas makers and purchasers commonly shared the interest in collecting coins, paintings, curiosities and other 'marvels' which would give rise in time to both the museum and the art gallery. Little wonder their atlases had such titles as *A Theatre of the Whole World*. These portable galleries brought the world into the scholar's or connoisseur's study. Prefaces of 16th and 17th century atlases commonly advertised their ability to relieve the reader from the fatigue and danger of travel to exotic places by opening the treasures of the earth to the immobile eye.

The idea that underlies *Artranspennine*, of exhibiting a region through strategically commissioned and positioned art works, is at once the latest expression and the complete inversion of those early modern cartographic projects. Today's regions cannot be represented through the kind of static, chorographic maps and descriptions that decorated the pages of early atlases or the walls of local dignitaries celebrating their locale. But the engagement of art with geographical representation – apparent for example in the current fascination of so many artists with maps and mapping – responds to similar imperatives of exploring and exhibiting the world, its regions and places, whether material or imaginative. And just as atlases played a significant role in mapping cultural identities into the geographical spaces of 17th century Europe, so regional galleries of the kind pioneered in *Artranspennine* might play a role in mapping today's mobile cultural identities across the flexible spaces of a 21st century world.

VISION AND THE 'CULTURAL' IN GEOGRAPHY: A BIOGRAPHICAL INTERVIEW WITH DENIS COSGROVE

Vision and the 'cultural' in geography:
a biographical interview with Denis Cosgrove *

TIM FREYTAG and HEIKE JÖNS

Getting engaged with geography

Liverpool

You are currently the Alexander von Humboldt Professor of Geography at the University of California at Los Angeles. How did you become interested in geography in the first place?

This is a question that I often have thought about – and of course to some extent one always invents these stories after the fact. But I normally think of three things that were important in growing up in the city where I grew up. This was Liverpool, which in the 1950s was the second largest port in what was then still the British Empire. First, Liverpool was the third largest city in England, it was a huge city, a mix of peoples and cultures from across Britain and also the world – places like New York and Cape Town seemed as close as London. Then, at the age of seven I was given a little toy globe that fascinated me. One of the things that attracted me about it was that all the little pecked lines of sea routes across the Atlantic had distances to Liverpool – Montreal was 3,100 miles away, Santiago 7,200 miles, and so on. So, here I was at the centre of the world. The globe told me that all routes went to my city. A third stimulus to geography was taking our Sunday walks along the river dock area and seeing these ships with extraordinary exotic names such as Lagos and Montevideo. This was my earliest experience of how the world was: a place whose difference was to be imagined long before it was experienced (we had no car, and I travelled no more than once a year outside the city, and no more than 100 miles from home in my first 15 years of life).

Then, it was a certain irony that in fact at the age of twelve under the English education system, I was obliged to give up the study of geography if I wanted to stay in the 'A' stream at my school. This was the time when children were ability streamed into A, B, C streams. I had done my first set of public exams, and if I wanted to continue in the A stream then I was forced to give up geography, because supposedly

* The following interview was conducted during the 8th Hettner Lectures at the University of Heidelberg, delivered by Denis Cosgrove in June 2005. It aims to offer insights into the interrelations between Cosgrove's biography and his scholarly work, and to stimulate a rethinking of different ways of practising cultural geography. The conversation was first published in *Die Erde* 136 (2005) pp. 205-216 and is reprinted here with the permission of the editors.

75

only the less intelligent students did geography. I had to take Latin and Greek and avoid geography. My mother went to my school to protest. And the priest who was the headmaster said to her 'Mrs. Cosgrove, geography is a girls' subject'. He would not get away with that kind of comment now, but it meant I didn't study geography for two or three years. But I actually read geography texts that I found by myself, regional textbooks on Brazil and Australia. And I was fascinated. I think it was the exoticism that captured my interest. I said that we didn't have a car and people did not move around very much, nor did we own a TV set. You lived a lot through your imagination, and I was always fascinated by the kinds of exotic that I encountered as a child where I grew up.

The education was important for the way my geography worked out, because it was a Jesuit school and therefore a great deal of attention was paid to theology and to ethical questions. My father, who was a bank clerk and who was very active in our upbringing, had also gone to this school. He was a deeply devout Roman Catholic, to the point where in the months of May and October we were on our knees saying the rosary every evening.

Oxford and Toronto

You were educated at St. Francis College, Liverpool (1959-1966) and went on to study geography at St. Catherine's College, Oxford (1966-1969) and the University of Toronto (1969-1970). How did your studies in these places shape your interest in cultural geography and in the study of landscape?

The beauty of the Oxford system is that it allowed you an enormous space just to be what you wanted. I did not find the geography taught there particularly inspiring, although I had a very good tutor, Ceri Peach. It was regional and systematic geography, and it was rather dull and to some extent a catalogue of facts. But we were aware of the current state of revolution in the discipline, of this exciting kind of theoretical stuff going on in geography at places like Cambridge and Bristol. I remember reading 'Central Places in Southern Germany' by Walter Christaller, which had just been translated in 1966. I liked the elegance of it, and I liked the graphics, but the mathematics and the logic behind did not particularly appeal to me. It seemed to me that geography, which I loved, wasn't doing the things that I loved about it. It seemed to have lost the sense of wonder, of the exotic, the rich tapestry of difference across the earth. This is what had drawn me to it.

When I did a Master's degree at the University of Toronto, it was towards historical geography that I was drawn. I also read a lot of critical landscape literature, but it was not written by geographers. It came from the 1950s and 60s, the names I remember are Gordon Cullen and Thomas Sharp. These were English architectural

writers who came out of a tradition of townscape and aesthetic planning. I think it's called *Stadtlandschaft* in German, where there was a similar tradition in the 1940s and 50s. It was an outcome of picturesque responses to the past, and of conservation ideals, and I remember coming across some of these ideas in photographic essays about the destruction of the English landscape. This seemed to me at least to be a kind of entry to things that appealed to me, but it was not in geography, it was in architecture. It did, however, introduce me to the idea that there was a more interesting historical geography than I had experienced in lectures at Oxford. So, when I went to do a Master's in Canada, I worked with Cole Harris and Jim Lemon, both of whom were historical geographers. Harris had us read people like Carl Sauer and Andrew Clark. American cultural geography had a well-defined tradition, while there was nothing in Britain called cultural geography. 'Cultural geography' didn't mean anything to me, the term didn't exist in my undergraduate education. I remember being taken on field excursions in Ontario, where you had to look at barn types – whether these were German barns, or Pennsylvanian barns or English barns. I mean, that was great in some respects, it was a kind of mapping exercise to be sure, but at least it was about actually being there, in the field, looking at the landscape and connecting different parts of the world in the material landscape, trying to make sense of it.

Why did you decide to do your Master's degree in Canada in the first place?

Actually, I didn't quite know what I wanted to do after university, but I was interested enough in learning to carry on in the academy. I was aware that there was funding in the United States and Canada, and I applied to three or four departments one of which was Berkeley. I was attracted by Berkeley partly because this was the 1960s, and, you know, California was an extraordinarily exciting place to be in the 1960s. They offered me a place, but they didn't offer me any funding. The University of Toronto did actually offer a teaching assistantship. So I could afford to go there. Later I found that Yi-Fu Tuan had been in Toronto, but he had left I think just before I arrived. I had read his paper, 'Topophilia'[1], I think just as I was leaving Oxford. So the influence was there and I began to read more of his work and shared his ideas with the other graduate students who were there: people like Edward Relph, for example, who was a year or so ahead of me. He suggested other readings in phenomenology, such as Bachelard and Eric Dardel. There was another Masters student, Leonard Guelke, who was in my year in Toronto, who has since written quite extensively on idealist history in geography. Another student, John Punter, later became a professor in the department of urban design at Reading. All of us were

[1] Yi-Fu Tuan, 'Topophilia', *Landscape* 11 (1961) pp. 29-32.

interested in similar things, which revolved around experiencing and imagining the world and questions of design which was an alternative to spatial science that dominated Toronto geography at the time.

Nevertheless, you went back to Oxford to do your PhD.

Well, there is a personal aspect to that. In fact, the woman who became my first wife had actually been a young lecturer at Oxford in my final year. Toronto wanted me to stay after the Masters. But we married and went back to Oxford. So, I went back more because I was going to be with my wife than for any particular intellectual reasons. And that was a problem for me because when I came back to Oxford on a state bursary and started talking about things like phenomenology and cultural geography, they had no idea what I was talking about. So I ended up giving up the bursary after one year and taking a job, which actually proved to be a very important decision in my development, at the Polytechnic of Central London (today Westminster University, London) in the architecture department. It was a research assistantship job on a computer modelling project to locate leisure centers in Westminster. This meant that I was trying to write the PhD thesis at the same time as doing the Westminster research. The one library that I had access to was the architecture library, and there I read Vitruvius, and Panofsky, and Cassirer, and a lot of architectural history, which gave me a specific take on the area that I had chosen for the PhD study: the landscape in Northeast Italy. How I made that choice is a complicated business but it was partly to do with becoming interested in Ruskin during my Masters' thesis on the warehousing district in Toronto. And then Ruskin led me to rethink my ideas on the English landscape and realise that many English landscape ideas had come from Italy. So that led me to Italy. But I had no training in any of the necessary skills for the research, I even had to learn my Italian from scratch on the streets.

You got your first job at Oxford Polytechnic in 1972. In which way did this job influence your academic career?

In terms of the longer career, Oxford Polytechnic was very important because I spent eight years there, one year of which I actually taught back in Toronto. I think those years were enormously influential in the sense that I was in a teaching institution. So it wasn't that I went directly into a research based department. There was no pressure to publish. At the same time as writing the PhD, I was teaching maybe fourteen, fifteen, sixteen hours a week, which is an extraordinary good training – and teaching right across from statistics to my own field. It kept me to a sense of the whole of geography. Sometimes I was even teaching physical geography, and teaching with some very interesting people like David Pepper, for example, who has written

influentially on environmentalism. Designing a whole curriculum, as we were also doing in the early years, was just very exciting and it gave me an enduring sense of the significance of teaching.

This job was also important because I had virtually no research supervision at Oxford. I didn't have what in Germany you call a doctor father – Oxford University forgot about me. My thesis was put in as a B.Litt., I was never upgraded to candidacy for the PhD. And it was only through the enormous courage and support of the external examiner, who was David Lowenthal, that I got a doctorate. He apparently read the thesis and said 'I am not going to examine this as a B.Litt. Take it out and make it a PhD, and then I will examine it'. So, in that sense I was able to be very independent. Teaching at Oxford Polytechnic also gave me a considerable freedom. It allowed me to do what I wanted, which was to follow a path that was a little bit idiosyncratic. The other thing the whole thesis experience gave me is – and I made a very clear commitment not to let my experience happen to others if I could help it – that were I ever to advise doctoral students I would take them seriously. I won't let a graduate student go through what I remember.

New cultural geography

Landscape

The central topics of your research have been landscape, its representation and the idea of landscape analysed within a Western European intellectual tradition. How does your use of the term 'landscape' relate to notions of 'space' and 'place'?

I stay with the term of 'landscape' partly because it is like a comfortable old coat that you have worn for so long that you have forgotten why you bought it. It's probably a little out of fashion and it got a few holes and a few stains, but it's still familiar. At Oxford University, I very nearly left geography because it seemed so distant from what I wanted to study and understand, and had I done so, I would probably have gone into language and literature. Obviously language has an aesthetic dimension and in the context of spatial science the word 'landscape' seemed to actually speak to what interested me. It had the affective emotional and aesthetic dimensions that I was searching for within geography. The discussion around 'place' was only just beginning. I mentioned Relph's book 'Place and placelessness' – his work sort of parallels mine – and place was his concern. [2] For me place always seemed much too small. It didn't have that broader sense and bigger picture that landscape had. It seemed much more focussed and local. And it was also tied to a sense of rootedness and identity that I was not really interested in.

[2] Edward Relph, *Place and placelessness* (London: Pion, 1976).

Space – I never had much interest in. It seemed to me to signify precisely the kind of disembodied, anti-humanist, abstract mathematical notion, an Euclidian mathematical discourse. And I still even have problems with spatialities, you know. I use the term because it is there, and addresses some of those affective aspects. But space to me still smacks of spatial science. The other thing about space and landscape is that landscape implies the natural world. We don't accept *Naturlandschaft* and *Kulturlandschaft* and all those kinds of distinctions – we have collapsed them – but nevertheless, hinted in the back of landscape – whether the material landscape or represented – is the natural world, the natural environment, the skies and trees and buildings and so on. This is not a necessary part of place, and certainly it is not necessary part of space. So landscape carries that sense of a tangible material world, which for me geography is rooted in and comes always back to.

What do you think is the value added of a particular geographical perspective on landscape in comparison to those of other disciplines?

I suppose it's precisely the connection with actual material places, and the environmental side. I am interested in questions of nature, and what David Livingstone called 'the geographical experiment': the relationship between various aspects of the human world – whether these are economic, social, cultural or imaginative – and the natural world. Now, I know all the discussions about how you can't make these separations and so on, but it seems to me this is where geography brings added value, because nature is at once material and cultural within geography. And when you talk to people in the humanities, when you talk to people in the arts, when you talk to people outside geography – let's say in cultural studies – that's often what they see is valuable in geography – that connection we still have to the natural sciences and environmental sciences.

Research traditions

Your work on the iconography of landscape has stimulated the development of a new cultural geography. Looking at this field as a whole, one can identify different strands such as the social and the cultural traditions. How do you think are these strands interrelated and how did you benefit from the other lines of interest in your field?

Well, new cultural geography isn't so new anymore, and I don't think I have ever actually used that phrase. It was dumped upon us. I think it was David Ley who actually used it for the first time around about 1988 or 89. Anyway, I think the iconography of landscape was only a part and possibly, as it has worked out, a rather minor part of the new cultural geography. Back in the 1960s, the term 'cultural' geography wasn't used in Britain (as I pointed out earlier in our talk), but there was a

tradition, which I think significantly was located largely in places like the University of Wales where H.J. Fleure and David Bowen had worked, or in the University of Ulster where Estyn Evans had taught. They shared an interest in culture and land, but of course in both cases these were precisely about minority cultures. They worked on the distribution of Welsh language or the 'personality' of Ulster, but they were not called cultural geographers and they represented a distinctly minor tradition.

When you talk about the social part of the phrase, there was a very strong tradition of social geography in Britain, and of course to a large extent, I was very closely in touch with it because my tutor as an undergraduate at Oxford was Ceri Peach. Ceri Peach was really doing some very pioneering work based upon the urban social school that came out of Chicago. He brought that up to date around questions of West Indian and South Asian immigration into Britain, which was a key issue of the 1960s, and he has remained at the forefront of that work. He produced from his graduate students a number of very significant contributors to contemporary social geography, like Peter Jackson and Susan Smith, both of whom many people would say are key figures in the 'new' cultural geography. That's interesting because although Peter and I in a sense both came from the same stable, I think the way that things have influenced us, and our concerns are very different. Peter is interested in the sociological questions surrounding culture. And I think he found his roots and origins in reading the Birmingham School for Contemporary Cultural Studies, people like Richard Hoggart and Stewart Hall, for example. This line of research is interested in popular culture, in questions of media, questions of literacy, questions of community and society – these are sociological questions and they are very much contemporary.

My own interest was more historical. I am not a historian and I don't write historical geography in the conventional sense of Clifford Darby and his students or even Sauer, Clark or Harris in the US. In terms of tradition (and this is where the influence of the Jesuit education comes in), I have much more a Catholic interest in ethical questions, and in a culture which is not national, but which is European, which demands an interest in languages and finds expression in literature and the visual arts, which deals with ideas. During my growing up, Rome was much more important than London. So, I have never really worked on England or Britain. This differentiates my work say from Stephen Daniels', whom I have worked with very closely. Steve has been very deeply and consistently interested in England, Britain and British culture. His approach in terms of historical, aesthetic and landscape aspects, is very close to mine, but his work is quite English – mine is not.

How did other cultural geographers comment on your particular approach to the subject?

A lot of people have often accused me of studying elite culture as if this were somehow wrong. But for me what is termed elite culture is more cosmopolitan culture, it's not populist. I don't see it as elite in the sense that it is actively and consciously exclusive, and in many of the images and things that I talk about and write about, say religious icons or traditions like utopian ideas, these were widely known and widely shared in the past, and not narrowly elite culture. So, I am going to be unhappy with that elite/popular distinction. In cultural geography actually the distinction comes precisely out of that critical Centre of Contemporary Cultural Studies perspective. So, I mean, it's a complicated argument. Also, I don't think that there was any real influence in Peter's work or Susan's work from the American cultural geography tradition with its roots in German landscape studies via Sauer. My sense is that what I call the social geography interest was always much more highly and immediately politicised. It buys into that ameliorative vision of geography, geography as something that should have planning or social impacts. But for me geography is not necessarily just about the need to change the world or to be radical (although I have been more sympathetic to that position in the past) – it's as much about changing ourselves and our thoughts, and also about citizenship in the world. So, it can be more of a self-reflective endeavour than about going out and materially changing the world. I don't know whether that's a kind of rather vague distinction, but I know that it's a very important one.

Based on a critique of iconographic research practices Nigel Thrift introduced research concepts into geography that stress the materiality of everyday practices and performances. According to him, 'Non-representational theory [...] is a radical attempt to wrench the social sciences and humanities out of their current emphasis on representation and interpretation by moving away from a view of the world based on contemplative models of thought and action towards theories of practice which amplify the potential of the flow of events.[3] *How would you respond to this critique of representational approaches and how would you position 'non-representational' ideas with regard to your work?*

Well, talking about what I understand non-representational theory to be, and the way I read this quote, I think it relates back to my answer to the last question, I am not particularly concerned with everyday practices. I am much more concerned with the history and evolution of ideas, and that again comes out of my early education. I think that ideas matter, ideas are active in the world. Unreflected, routinized and unexamined everday life does not strike me personally as very interesting. Whereas that social geography tradition believes much more in practices, in action and

[3] Nigel Thrift, 'Non-representational theory', in R.J. Johnston, Derek Gregory, Geraldine Pratt and Michael Watts (eds.) *The dictionary of human geography* (Oxford: Blackwell, 2000) p. 556.

possibly conceives of thought or sees thought as subordinate to action, I don't – I think ideas are important agents in the world even if they cannot be immediately linked to embodied practice. I am much more interested in the ideas that lie behind something than the thing itself. On the other hand, I think that there are some very interesting geographical writings that have emerged from this theoretical shift and its reworking of phenomenology in geography, for example John Wylie's recent writings on polar exploration and the experience of walking;[4] but these are not un-reflective acts, they are highly-wrought both intellectually and stylistically.

I don't myself see a need to be 'wrenched out' of an emphasis of contemplative modes of thought. It's fine if Nigel wants to do it but I resist the idea that it somehow advances on other modes, as if geography were like the natural sciences, always searching for an intellectual revolution that will abandon prior theories and insights. I am actually intrigued by that word 'wrench'. It's a very violent word, it's a violent verb. And it suggests somehow a kind of critical and somewhat aggressive stance. Interestingly, the word critique that you use in your question is another example of the same tenor of theoretical work. This appallingly misused French word, has completely displaced the perfectly good English word 'criticism'. Even in popular discussion now on the radio in America people don't criticize each other's thinking – they 'critique' it. But the usage is very telling, because critique is about ideology, politics, action and power, rather than thoughtful exposition of strengths and failings and judging an idea or argument or other piece of work by its own declared goals, which is criticism. Critique suggests to me a particular way of thinking about the world that doesn't see things as conversation, that distrusts things as they are intended in a flow of ideas, but sees everything as social action and works with a kind of instrumental vision of things. And that worries me because I think there is a role for the contemplative, there is a role for self-reflexion and thoughtful, critical conversation.

It's interesting that Nigel in that quote rolls the social sciences and humanities into one. Now, I think one of the really interesting things that has happened in the last twenty or thirty years has been the ways in which humanities have had to come to grips with and respond to social theory and critical theory, and by the same token the way that social sciences have had to take culture seriously. But nevertheless, I don't think it's right to simply roll them together. They still have different attitudes and stances towards the world.

[4] John Wylie, 'Becoming-icy: Scott and Amundsen's South Polar voyages, 1910-1913', *Cultural Geographies* 9 (2002) pp. 249-265; and 'A single day's walking: narrating self and landscape on the South West Coast Path', *Transactions of the Institute of British Geographers* 30 (2005) pp. 234-247.

In his biographical essay on you as a key thinker on space and place, Keith Lilley characterized your work as one of the most important sources of inspiration for those geographers seeking to interrogate the imbrication of knowledge and power.[5] Which role do issues of power play in your work?

I think what he is talking about there is really the impact of my book 'Social formation and symbolic landscape'[6], which very clearly was about knowledge and power. Certainly many people, also in landscape work beyond geography, have taken that focus to develop the knowledge/power aspects of the book. For me, I think, issues of power are unavoidable. But – power is an extraordinarily complicated concept. So, we can talk about political power, we can talk about coercive or oppressive power, we can talk about power in the sense of empowerment. And I guess, as Foucault points out, power is everywhere and always moving within any relation. So, in that sense it's unavoidable. On the other hand, I feel that the focus on power as the principal mechanism of relationships, personal and social relationships and our relationships with the external world, has been overplayed to the extent that it has tended to subordinate other equally important things. When I think about, say, Steve Pile's focus on other questions, of memory and psychology, on haunting and so on, and on the return to phenomenology, this is a very interesting opening. The focus that gender and particularly queer studies have brought in to questions of desire is very important – even if sometimes that too gets reduced back into power. I think that there are other questions that have much more to do with the individual, much more to do with self-reflexion. These questions deal with our relations with ourselves and our contemplation of ourselves and our searching for what Yi-Fu Tuan would have called the 'good life'. What does it mean to live a good life, or more accurately the 'examined' life? I don't think these are necessarily reducible to questions about power. Power is important, but it tends to push us towards the concerns of social geography.

Now, I resist the notion of humanistic geography, because that is too labelled by a certain moment and set of concerns in the 1970s that betokens a kind of warm, fuzzy, and universalistic approach that actually evaded issues of power. There is no question that humanities were and always have been deeply associated with power. Humanists in the 15th and 16th centuries educated kings and nobles precisely for the exercise of power. But it was also about self-knowledge and, as I say in one or two recent papers, there is the Stoic tradition in geography which is deeply rooted in humanism and which interests me particularly because it's a more contemplative

[5] Keith Lilley, 'Denis Cosgrove', in Phil Hubbard, Rob Kitchin and Gill Valentine (eds.) *Key thinkers on space and place* (London: Sage) pp. 84-89.

[6] Denis Cosgrove, *Social formation and symbolic landscape* (London: Croom Helm, 1984).

science that has largely been written out of recent histories of the discipline. Italian Renaissance humanists used to make that distinction between *la vita activa,* the active life, and *vita contemplativa,* the contemplative life, and regarded the fulfilled life to be balanced between both. I think probably since the early 1970s, when David Harvey and others claimed the project of geography should be about public policy, has geography committed itself perhaps too fully to *la vita activa* and has ignored *la vita contemplativa.* And that's important because that's also about the didactic between the research and the educational sides of geography. This brings me back to a couple of points that I made earlier: Eight years at Oxford Polytechnic led me to the belief that if graduates are to be properly trained they need to be taught about geography as a learning practice, not simply a research project. It seems to me that the impact of my geography is realised primarily in the classroom, or by students reading my work. It's not in policy; it's not in changing social relations, or in liberating one particular oppressed minority or another.

Aesthetics and the visual

Another important topic in your work concerns questions of aesthetics.

Yes, aesthetics is important because I think that the true, the beautiful and the good are connected in some way. And in the western tradition it has always been recognized that they are connected. I remember being very upset with this term that is used by some geographers: 'aestheticization'. Aesthetisizing something is seen as a negative thing, it is a way of criticizing work. It implies that somehow the 'real', i.e. the real nastiness, the real issues of power, etc. are hidden by a pleasing surface. You only have to look at say fascism here in Germany in the 1930s to see that aesthetics *can* act in that way, to cover over the surface much deeper evils. But I think that's again to narrow it down, to miss the liberating and the consolatory power of beauty. And we don't often talk about consolation. I mean we live in a hard and difficult and often tragic material world where we all suffer setbacks and sadnesses and tragedies. We need consolation, and beauty gives us consolation. There's beauty in what we as geographers study, and to deny it and remove it or say 'It's always a veneer for something else, it's a distraction' rather than taking it seriously is to miss out on some really important questions, and to do ourselves a disservice.

Recently there have been debates within the discipline about visual methodologies in geography[7]. *Which role do you ascribe to the visual in geography?*

[7] Gillian Rose, *Visual methodologies: An introduction to the interpretation of visual materials* (London: Sage, 2001), and 'Just how, exactly, is geography visual?', *Antipode* 35 (2003) pp. 212-221; see also

I think it has always been if not central, very, very important. The common sense meaning of geography is related to maps, it's related to places, it's related to representing things visually. Certainly what got me into geography was the world I see around me – both in its material self and also through maps. Now, I know that there are many other people in geography for whom the visual is not that significant. But I find it very hard to conceive of a geography where the visual does not play a very important role – that's not to say that it should overwhelm things. I am aware of all the criticism of the visual, and I am conscious that in the western tradition the visual has long been related to seeing, has been related to knowing, has been a particular kind of epistemology – the epistemology itself then being related to particular forms of power in capitalism or in imperialism. And I don't deny this, I don't say that it is not true, but the visual also incorporates 'vision' and vision is much more than optical, it embraces the fact that seeing and picturing are as much acts of imagination as of perception. I suppose we all within the discipline have to make our choices, and for me, I can't conceive of a geography that I could practice, in which questions of vision, the visual and the graphic are not absolutely central. Images play a lot of very different roles for me, and seeing and the sense of sight are, undoubtedly, very important to me.

Geography and the humanities

Collaborations

In which ways have you co-operated with researchers from other disciplines, and in particular from the arts and humanities?

I interact and collaborate a great deal. I often get asked to talk to groups in cultural studies, in history, in art history and architecture, in landscape architecture – even, more recently, in literary studies. These are people who read my work or some of it, and for whatever reason find it interesting and ask me to come and talk. And of course I am happy to do that, and I learn a great deal from them. In the early days I used to be quite intimidated as one is when going outside one's discipline, but then you find people are genuinely interested in your work and they are interested in your reactions to their own work. So, I guess, my geography has been interdisciplinary, but not because I intended it consciously to be so. Actually, let's go back to when you asked me about Oxford Polytechnic – I am thinking what a great thing being at Oxford Polytechnic as a very young academic was, that I didn't have my own office. I actually shared a large office with all the lecturers of the department of Arts and

contributions by Matless, Driver, Ryan and Crang to 'Intervention roundtable: geographical knowledge and visual practices' in *Antipode* 35 (2003) pp. 212-243.

Languages. So, there were lecturers in German, in History of Art, in French literature, there were lecturers in English literature, in History, in Law, and in Italian. And, you know, I worked in this office for my first four years, and it didn't give you much time to do your own research. But what it meant was that you were hearing them discussing their teaching, you were talking with them, and you were genuinely part of something that was a group of people in the humanities. And the undergraduate degree that we were constructing at the time was a modular, American style degree, so you had to talk with each other. I literally spent the first five or six years of my career day-to-day with people in other disciplines, in the disciplines of the arts and humanities.

I have also collaborated since with people in the arts in a number of ways, writing, for example, catalogue essays for painters, and I have just completed two others for art photographers. I have done some curating of art works and exhibitions. And in Los Angeles, a number of my students have come from places like the Harvard School of Design, and are practicing artists and architects. Out of my PhD students, four have been trained landscape architects. They bring as much to me as I can give to them. So, yes, it's a close collaboration – in a number of ways.

When you think about your experiences with interdisciplinary collaboration, what was the particular geographical perspective you brought to these interdisciplinary projects?

My sense is that there are two things that people in other disciplines like from geographers today. One is that when we talk about things like space and place, we do actually have a sense of the real, material world. Most of us have some training in physical geography. We have that kind of *Zusammenhang*, that sense that everything links together – from nature and culture – and this is not something other disciplines do. Interestingly, just as we sometimes are tempted to abandon that aspect of our tradition, it's what they often find is powerful from geographers. The other thing in this context is that the very serious and thoughtful geographical interrogation of space from people like David Harvey, Ed Soja and others has been widely recognized to be an important contribution well beyond geography. Geographers have thought about space very deeply, not like philosophers, but as a kind of social entity that references the actual world, space considered in a much more fertile and serious way than almost anybody else, particularly architects who think about space rather differently.

Where do you see the challenges for cultural geography within the humanities' tradition in the early 21ˢᵗ century?

I think one of the challenges – probably the primary one – is actually to keep the humanities' tradition alive within cultural geography. So, I would reverse your question and say the challenge isn't for new cultural geography within the humanities' tradition. It is for the humanities' tradition within cultural geography. This is the first thing, and it obviously means interrogating what we mean by the humanities' tradition, thinking very carefully and thoughtfully about how it speaks to the contemporary world and contemporary students. It is, for example, very easy for me to go back and talk about the 16th century, I feel happy and familiar in there. But the challenges of the contemporary world are different. They are also the same, I mean the issues of 'Who are we in relation to the world? How should we live our lives in a way that is fulfilling and morally proper?' remain (who the 'we' is will of course be differently answered by each person, but for all our 'positionalities' each of us geographers share much the same world). Cosmopolitanism represents I think a significant recent debate, in which geographers have insufficiently engaged. But I think it's still a fundamental one and certainly a fundamental one for me living in Los Angeles. Los Angeles is today what much of the world is going to be like in the new century, in terms of the mixture of cultures and peoples. So, I think it is important to reframe those very enduring questions which have been addressed particularly in Stoicism, for example. I am not a practising or even a believing Catholic, but I share that kind of Stoic, Jesuit concern with education as something that feeds the soul and the mind and the body together, and that is ultimately about how we should live our lives.

When I talk about geography as a humanity, I see geography as addressing in its own way and with its own techniques and with its own particular objects of interest the same questions as the study of literature or of history, the proper study of which is – to use an old gendered way of saying it – 'Man'. Or you might say, the proper object of the humanities is our human selves. This begs of course the question 'What makes us human?' – and to me that's central to all this; for geographers it is living in relationships with the material world that are as much imagined as practiced. That's the challenge, I think, in a geography that is constantly pulled towards the instrumental. And that's not to say it should not be instrumental at all. I know that the kind of geography I am talking about here will always be a minor part of the bigger project, and I am not pretending it should be anything other than that, but I think those matters should be at the very heart of the geographical project.

KLAUS TSCHIRA FOUNDATION

The Klaus Tschira Foundation gGmbH

Physicist Dr. h.c. Klaus Tschira established the *Klaus Tschira Foundation* in 1995 as a not-for-profit organization designed to support research in informatics, the natural sciences, and mathematics, as well as promotion of public understanding in these sciences. Klaus Tschira's commitment to this objective was honored in 1999 with the "Deutscher Stifterpreis" by the National Association of German Foundations. Klaus Tschira is a co-founder of the SAP AG in Walldorf, one of the world's leading companies in the software industry. After many years on the board of directors, Klaus Tschira is now a member of the company's supervisory board.

The Klaus Tschira Foundation (KTF) mainly provides support for research in applied informatics, the natural sciences, and mathematics, and supports educational projects for students at public and private universities and at schools. In all its activities, KTF tries to foster public understanding for the sciences, mathematics, and informatics. The resources provided are largely used to fund projects initiated by the Foundation itself. To this end, it commissions research from institutions such as the *EML Research,* founded by Klaus Tschira. The central objective of this research institute of applied informatics is to develop new information processing systems in which the technology involved does not represent an obstacle in the perception of the user. In addition, the KTF invites applications for project funding, provided that the projects in question are in line with the central concerns of the Foundation.

The home of the Foundation is the Villa Bosch in Heidelberg, the former residence of Nobel Prize laureate for chemistry Carl Bosch (1874-1940). Carl Bosch, scientist, engineer and businessman, entered BASF in 1899 as a chemist and later became its CEO in 1919. In 1925 he was additionally appointed CEO of the then newly created IG Farbenindustrie AG and in 1935 Bosch became chairman of the supervisory board of this large chemical company. In 1937 Bosch was elected president of the Kaiser Wilhelm Gesellschaft (later Max-Planck-Gesellschaft), the premier scientific society in Germany. In his works, Bosch combined chemical and technological knowledge at its best. Between 1908 and 1913, together with Paul Alwin Mittasch, he surmounted numerous problems in the industrial synthesis of ammonia, based on the process discovered earlier by Fritz Haber (Karlsruhe, Nobel Prize for Chemistry in 1918). The Haber-Bosch-Process, as it is known, quickly became and still is the most important process for the production of ammonia. Bosch's research also influenced high-pressure synthesis of other substances. He was awarded the Nobel Prize for Chemistry in 1931, together with Friedrich Bergius.

In 1922, BASF erected a spacious country mansion and ancillary buildings in Heidelberg-Schlierbach for its CEO Carl Bosch. The villa is situated in a small park on the hillside above the river Neckar and within walking distance from the famous

Heidelberg Castle. As a fine example of the style and culture of the 1920's it is considered to be one of the most beautiful buildings in Heidelberg and placed under cultural heritage protection. After the end of World War II the Villa Bosch served as domicile for high ranking military staff of the United States Army. After that, a local enterprise used the villa for several years as its headquarters. In 1967 the Süddeutsche Rundfunk, a broadcasting company, established its Studio Heidelberg here. Klaus Tschira bought the Villa Bosch as a future home for his planned foundations towards the end of 1994 and started to have the villa restored, renovated and modernised. Since mid 1997 the Villa Bosch presents itself in new splendour, combining the historic ambience of the 1920's with the latest of infrastructure and technology and ready for new challenges. The former garage situated 300 m west of the villa now houses the Carl Bosch Museum Heidelberg, founded and managed by Gerda Tschira, which is dedicated to the memory of the Nobel laureate, his life and achievements.

Text: Klaus Tschira Foundation 2006

For further information contact:

Klaus Tschira Foundation gGmbH
Villa Bosch
Schloss-Wolfsbrunnenweg 33
D-69118 Heidelberg, Germany
Tel.: (49) 6221/533-101
Fax: (49) 6221/533-199
beate.spiegel@ktf.villa-bosch.de

Public relations:
Renate Ries
Tel.: (49) 6221/533-214
Fax: (49) 6221/533-198
renate.ries@ktf.villa-bosch.de

http://www.villa-bosch.de/

PHOTOGRAPHIC
REPRESENTATIONS

Photographic representations: Hettner-Lecture 2005

Plate 1 Denis Cosgrove in the *Alte Aula*.

 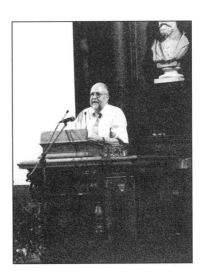

Plate 2 & 3 Peter Comba, Vice-Rector; Klaus Tschira, President KTF.

Plate 4 Reception in the *Bel Etage*.

Plate 5 Discussion in the departmental gardens.

Plate 6 Second lecture, *Geographisches Institut.*

Plate 7 Public debate with Denis Cosgrove, chaired by Benno Werlen

Plate 8 Seminar in the studio of the *Villa Bosch*.

Plate 9 Seminar discussion.

98

LIST OF PARTICIPANTS

List of participants

The following graduate students and young researchers participated in one or several of the three seminars with Denis Cosgrove:

ADAMEK-SCHYMA, Bernd; Leibniz Institute of Regional Geography, Leipzig

BELYAEV, Demyan; Department of Geography, Heidelberg

BERWING, Stefan; Department of Geography, Heidelberg

FREIHÖFER, Jana; Department of Geography, Heidelberg

FREYTAG, Tim; Department of Geography, Heidelberg

FRICKE, Katharina; Department of Geography, Heidelberg

FUENTENEBRO, Pablo; Université de Paris, Paris

JAHNKE, Holger; Stuttgart

JÖNS, Heike; Department of Geography, Nottingham

KLUMPNER, Paul; University of Innsbruck, Innsbruck

KUSZTOR, Adél; Department of Regional Geography, Eötvös Loránd University, Budapest

LOSSAU, Julia; Department of Geography, Heidelberg

LUGINBÜHL, Anne; Department of Geography, Berne

MAGER, Christoph; Department of Geography, Heidelberg

MATTISSEK, Annika; Department of Geography, Heidelberg

MEYER ZU SCHWABEDISSEN, Friederike; Leibniz Institute of Regional Geography, Leipzig

NIKITSCHER, Péter; Department of Regional Geography, Eötvös Loránd University, Budapest

PROSSEK, Achim; Faculty of Spatial Planning, Dortmund

SCHLOTTMANN, Antje; Department of Geography, Jena

SCHMID, Heiko; Department of Geography, Heidelberg

SCHMID, Stella; Berlin

SCHRIRE, Dani; Department of Geography, Jerusalem

SPYCHER, Tonia; Department of Geography, Berne

WUNDER, Edgar; Department of Geography, Heidelberg

WOLKERSDORFER, Günter; Department of Geography, Münster

Plate 10 Some participants of the Hettner-Lecture 2005.

HETTNER-LECTURES

Please order from: *Franz Steiner Verlag GmbH / www.steiner-verlag.de*
Distribution by Brockhaus / Commission, Kreidlerstraße 9, D-70806 Kornwestheim
E-Mail: bestell@brocom.de Tel. 0049 (0)7154 1327-0 Fax 0049 (0)7154 1327-13